IMAGES
of America

MANHATTAN
STREET SCENES

Barry Moreno

D1419181

ARCADIA
PUBLISHING

Published by Arcadia Publishing
Charleston SC, Chicago IL, Portsmouth NH, San Francisco CA

Printed in the United States of America

Library of Congress Catalog Card Number: 2006921066

For all general information contact Arcadia Publishing at:
Telephone 843-853-2070
Fax 843-853-0044
E-mail sales@arcadiapublishing.com
For customer service and orders:
Toll-Free 1-888-313-2665

Visit us on the Internet at http://www.arcadiapublishing.com

Dedicated to Joseph Michalak
and the New York Police Department.

CONTENTS

ACKNOWLEDGMENTS

My thanks are due to the many who have kindly assisted me in this project, especially my editor at Arcadia Publishing, Erin Vosgien, and also proofreader Sarah Gabert. In addition, I should like to thank David H. Cassells, Irving Silberg, Deborah Falik, Richard D. Holmes, Eric Byron, Jeffrey Dosik, Charles "Chick" Lemonick, John Kiyasu, Marcus Smith, North Peterson, Philip Rayfield, Diana Pardue, Kevin Daley, Frank Mills, George Tselos, Janet Levine, Sydney Onikul, Doug Tarr, Ken Glasgow, Judith Giuriceo-Lord, Paul Roper, David Diakow, David McCutcheon, Catherine Daly, Douglas Treem, Don Fiorino, Isabel Belarsky, Jose Valencia, Kathleen Donovan, George Gordon, George Hennessey, Mario Torricella, Jacob Auerbach, Emelise Aleandri, Wiley Steve Thornton, Michael Schrader, Edward Harrington, the late Arthur Tracy, and Neil Clementson. These and numerous others have generously shared with me their knowledge of Manhattan.

INTRODUCTION

From uptown to downtown, from east side to west side, this volume will show you the many moods of old Manhattan and the life of its people in years long since gone. In fact, the photographs within these pages were all taken in the years that span the 1860s through the 1960s, an age when New York—which to everyone meant Manhattan—had already achieved universal recognition as one of the globe's foremost cities. Through the miracle of photographic tableaux, this book chronicles that exceptional time—an era when Manhattan's magnificent skyline was still unique in the world, when its celebrated ticker tape parades thrilled the city, and when the glitter of Times Square and its theaters and the multitude of motor traffic and pedestrians crowding its thoroughfares emphasized its role as the chief American metropolis. Aside from the images that tell something of that story, this book also contains unusual pictures seldom seen. Among them are some 70 rare police and crime photographs that show events occurring in a time far removed from our own.

Although the city of New York embraces five grand boroughs, its greatest by far is Manhattan, for it was there that New York City saw its initial development, first as a Dutch colonial town called New Amsterdam and later as the namesake city of England's Duke of York. Over the course of decades, the community underwent phenomenal growth and change and soon developed into a formidable hub of world trade and industry as well as the continent's greatest metropolis. Although a burgeoning population—often of migrants both from within the country and abroad—placed a great strain on the city's resources, it usually found solutions to deal with these difficulties. As it matured, Manhattan also attracted the liveliest arts (drama, music, literature, and dance), as well as merchants, investors, and intellectuals. There, too, political power took many forms, from the old days of Tammany Hall to the installation of the United Nations following the end of World War II.

For those wishing to gain an understanding of that most extraordinary of places, there can be no more revealing a form—at least in still art—than in glimpses of the past as preserved by photography. Pictures of old Manhattan possess a strange and illusive vibrancy, one that suggests why the place attracted the critical attention of so many generations of artists, writers, musicians, and others of their kind. And although pictures needs must tell only bits and pieces of life, they have the wonderful capacity of encouraging the imagination to envision other scenes of city life, even if only in dreams.

Taken by a great many cameramen and camerawomen, the pictures appearing in this book were produced over a span of more than 80 years. During that time, the photographers observed and documented the great city in the throes of its expansion and development. They documented its inhabitants as they went about their affairs, almost entirely unconscious of the scrutiny. These images are not only relevant to the story of New York but are also highly relevant to the

history of North America as a whole, the continent where millions of peoples—both native born and foreign—were to leave their mark and so influence the generations and individuals that have followed.

Each of the 10 chapters in this book discloses a unique vision of Manhattan. The first focuses on some of the most recognizable buildings and landmarks of the city, such as its churches, skyscrapers, and docks. The second chapter leads you into a world of merchants and small-time tradesmen. Included are small businesses such as drugstores and delicatessens, as well as firms that operated on a somewhat grander scale, such as hotels and factories. Included for variety are interesting shots of street peddlers: shoe-shine boys, icicle sellers, and newsagents. The third chapter presents the Manhattan so familiar to us all, its teeming crowds and traffic, from Times Square to Fifth Avenue to 135th Street. Chapter 4 highlights vehicles that commonly moved about the streets: horse-drawn cabs and carriages, wagons, and a rich variety of motor vehicles. The succeeding chapter presents rare photographs of police work, including crime fighting, traffic control, and the special work of women police. From 1910 to 1940, New York's police force rose steadily from 10,173 officers to 19,747 (today there about 37,000). Image after image reveals visible aspects of their daily tasks and the construct of police life as a whole: the training of freshly selected recruits, the architectural features of police station houses (including interior scenes of desk sergeants and doormen), and the various steps in dealing with crime and criminals. Crime-fighting imagery includes scenes of crime laboratory experts at work, of officers administering a polygraph test to a suspect, of old-time mug shots, and the scenes of an old-fashioned identity parade, which is also known as a police lineup. These ways of searching out and detecting criminals were further bolstered by other technical advances that were available in the same period. They included fingerprinting (adopted after 1900), traffic control (1908), a bomb squad to fight anarchists (1914), radio motor patrol cars (1917), and an Air Service Unit replete with small airplanes and helicopters (1927). One of the more prominent police commissioners, Arthur Woods (1870–1942), who served from 1914 to 1918, was responsible for better police training when as deputy commissioner he introduced a police academy largely based on the standards of the greatest police force in the English-speaking world, Scotland Yard. The role of police and safety is yet another topic covered in this chapter. Much of this is centered on traffic safety and the dangers of car smashups and crashes. Since police work in the 20th century would not have been truly effective without proper means of transport, the role of horses and early police patrol vehicles are examined as well. This section is further strengthened by the inclusion of images that in a sense recount the exceptional work of women attached to the police force both as matrons and as policewomen themselves.

Chapter 6 covers aspects of immigrant life in Manhattan and includes scenes of Little Italy, Little Syria, and the Jewish Lower East Side. The daily life for poorer immigrants is revealed in scenes of tenement life. Children's lives are shown in the next chapter. Their schooling, work, and games are the central topics in this section of the book.

Chapter 8 shows that even Manhattan has some moments of repose and peace in at least a few of its streets. The ninth chapter highlights the world of entertainment, from legitimate theatrical productions to vaudeville to nightclubs. For instance, recalling the glory of the New York Hippodrome and the glamour of flappers brings that lost world to life once more. The book closes with a chapter on parades and public spectacles. Ticker tape parades are an old tradition in New York, and this chapter shows a parade that celebrated the "war to end all wars." In sum, *Manhattan Street Scenes*, through a series of fading pictures of long ago, recaptures old Manhattan while it was still fresh and young.

One

BUILDINGS AND LANDMARKS

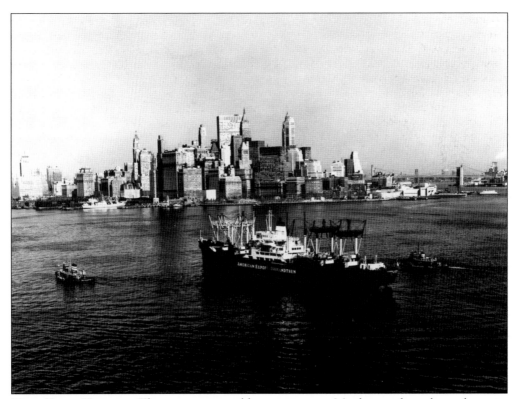

NEW YORK HARBOR. The most memorable entrance to Manhattan has always been its magnificent harbor. Years ago, its preeminence in the field of international shipping made this port the chief entranceway to the United States from overseas. (National Park Service.)

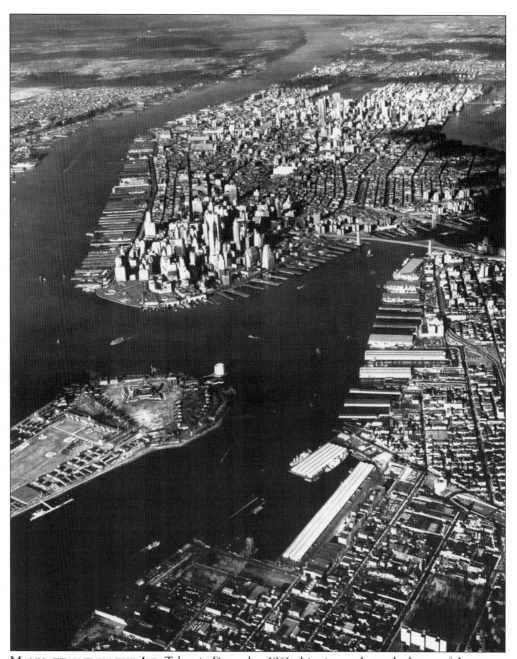

MANHATTAN FROM THE AIR. Taken in December 1961, this picture shows the layout of the streets of Manhattan Island; it also provides a wonderful view of the inner harbor, Governors Island, the Brooklyn Marine Terminal, nearby docks, the East River, the Brooklyn Bridge, and, on the upper left, the Hudson River and a portion of Hoboken, New Jersey. (Port of New York Authority.)

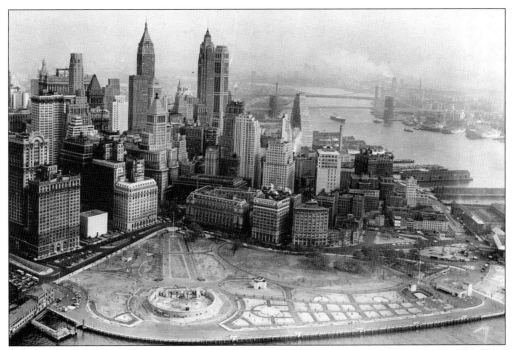

AN AERIAL VIEW OF BATTERY PARK AND LOWER MANHATTAN. This view of some of the streets and buildings on the west side of lower Manhattan was taken in the late 1950s. (The New York Times.)

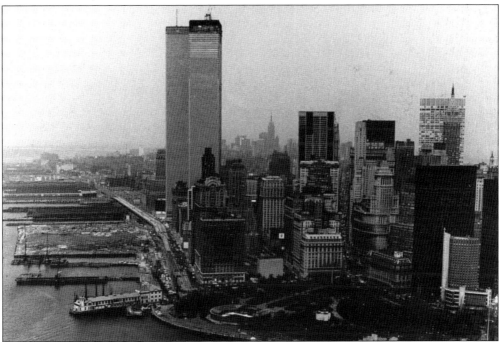

WEST SIDE PIERS AND THE WORLD TRADE CENTER. This picture is from the 1970s. Although the newly constructed World Trade Center visually dominated the scene, the older buildings and streets of lower Manhattan tell a richer story. (National Park Service.)

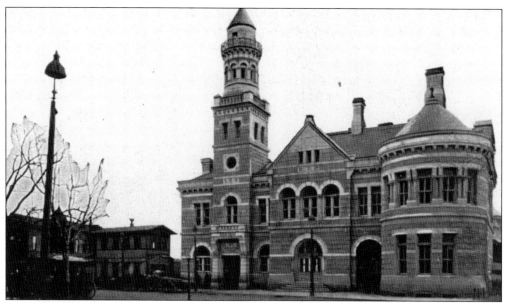

THE BARGE OFFICE: GATEWAY TO MANHATTAN. Constructed by the U.S. Department of the Treasury in 1882, the Barge Office stood at the bottom of Battery Park and was the landing place of immigrants just released from Ellis Island, from 1892 to 1911. It also served as a temporary federal immigrant inspection station from 1890 to 1892 and from 1897 to 1900. During most of the Ellis Island years, it was used as office space for officers of the Customs Service, for inspectors of the Bureau of Immigration, and for a team of Marine Hospital Service surgeons attached to the Bureau of Immigration. It was demolished in 1911. (National Park Service.)

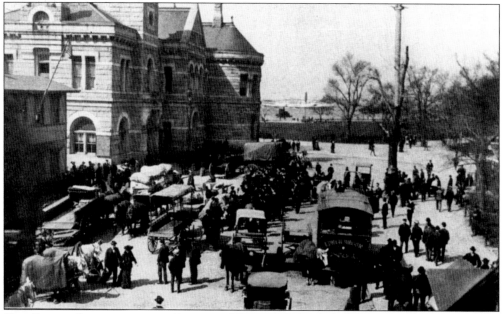

THE BARGE OFFICE AND THE BATTERY. Here newly landed aliens just released from Ellis Island congregate in front of the Barge Office. The space between the Barge Office and another building, through which people are exiting, gave access to the Ellis Island ferry. This picture dates from around 1906. (National Park Service.)

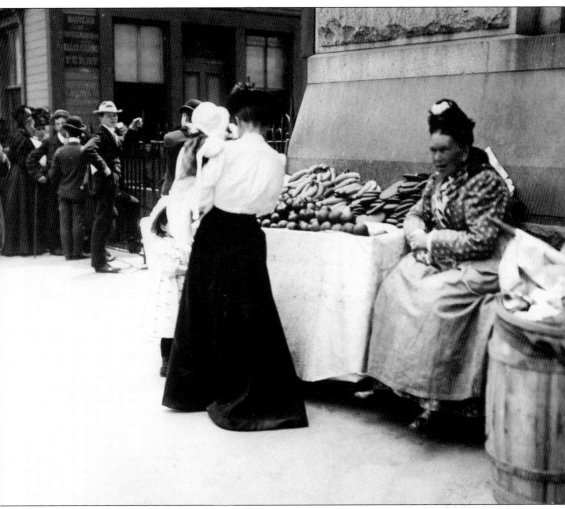

JANE NOONAN. This street scene shows 70-year-old Jane Noonan, an Irish immigrant who sold apples in front of the Barge Office. This picture shows her fruit stand as it appeared in 1900, when it stood in front of the Barge Office, near the entrance to the Ellis Island ferry. Years before, she had sold her fruit inside of the Castle Garden Immigrant Station. In 1906, the U.S. Department of the Treasury forced Noonan to move her trade elsewhere.

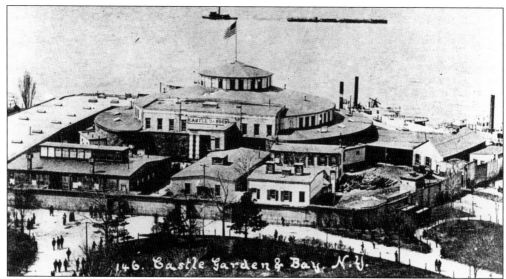

CASTLE GARDEN IN 1888. One of Manhattan's oldest landmarks, Castle Garden, located in Battery Park, was originally built as a fortress. After being closed by the military in 1823, it became a public events center and, in 1839, a concert hall. During these years, colorful events were held there, including formal receptions for France's Marquis de Lafayette (1824) and U.S. presidents Andrew Jackson (1833), John Tyler (1841), and James K. Polk (1847). The picture shows the castle at the time that it was the New York State Emigrant Depot. After having served as the nation's first immigrant landing station (1855–1890), it then became the very first city aquarium in the country (1896–1941). In 1950, Pres. Harry S. Truman proclaimed it a national monument under its old military name, Castle Clinton. (National Park Service.)

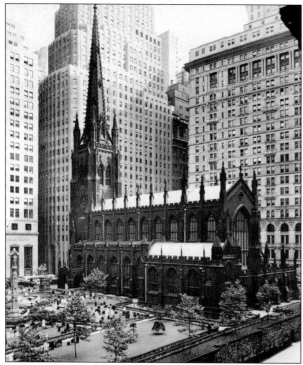

TRINITY CHURCH. Designed in the Gothic Revival style by English-born architect Richard Upjohn, Trinity Church is one of the best known of Manhattan's Protestant Episcopal churches. Its churchyard contains the graves of such well-known Americans as statesman Alexander Hamilton, inventor Robert Fulton, poet Clement Clarke Moore, and the merchant John Jacob Astor. The picture dates from the 1940s. (National Park Service.)

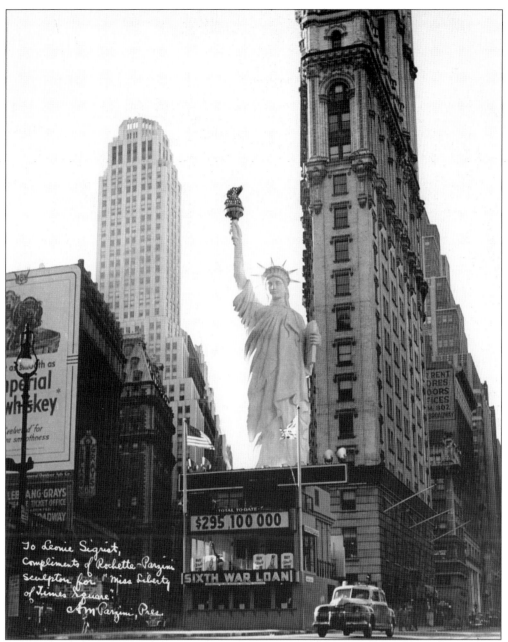

LIBERTY AT TIMES SQUARE. During World War II, the federal government raised money by selling Liberty Bonds; the symbol of the effort was naturally the Statue of Liberty. The firm of Rochette-Parzini sculpted this enormous model of ancient Rome's goddess of freedom. The original statue in the harbor was the work of French sculptor Frédéric-Auguste Bartholdi and was constructed in 1886. (National Park Service.)

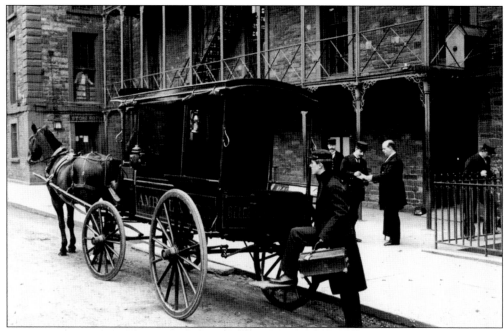

Bellevue Hospital Ambulance. This horse-drawn ambulance was photographed at Bellevue Hospital in 1896. The hospital, located at First Avenue and 27th Street, had originally opened at another site in 1736. Bellevue was the first American hospital to establish its own ambulance service (1869). (National Park Service.)

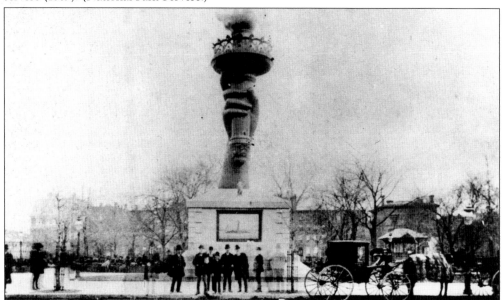

Liberty's Torch at Madison Square, 1877. The Statue of Liberty's torch was the first part of her to visit America. It was first displayed at the America Centennial celebration in Philadelphia. After the fair closed, it was brought to New York and displayed at Madison Square. After having been returned to France in 1882, it was brought to New York once again—this time with the rest of the Goddess of Liberty—and unveiled at Bedloe's Island in New York Harbor in 1886. (National Park Service.)

16

Two

TRADE AND COMMERCE

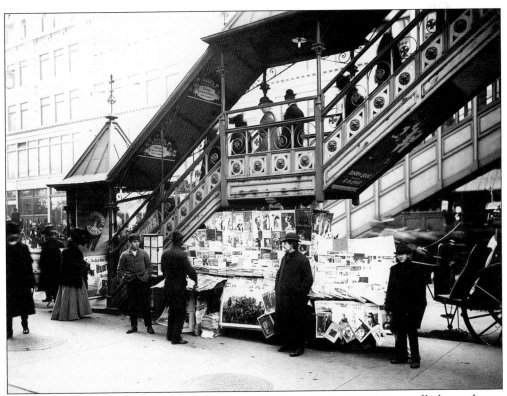

MANHATTAN NEWSSTAND IN 1903. This newsagent's business was strategically located near the entrance to an elevated railway station. Periodicals on sale include *Argosy, Collier's, Harper's Weekly, Pearson's, Tatler, Success, Police News,* and the *Magazine of Mysteries.* Note also the advertisements for Floradora Cigars and Knox's Gelatin, the latter of which promised to "change a prosy meal into a poem." (Library of Congress.)

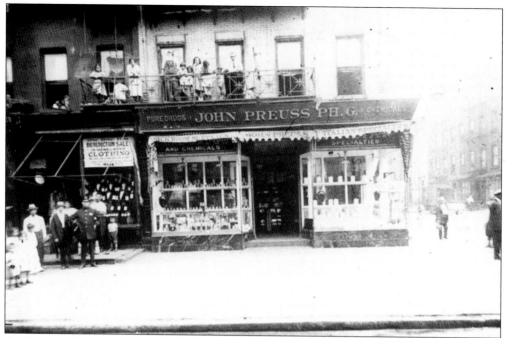

A Corner Drugstore. Pictured here is the pharmacy of John Preuss, which offered "pure drugs," "chemicals," and "specialties" for sale. The picture dates from about 1918.

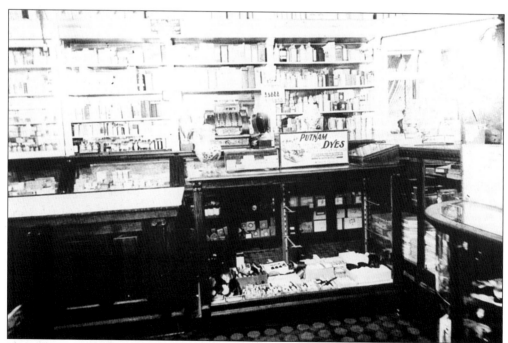

Inside Preuss's Drugstore. Along with expected goods such as Putnam Dyes, the sign behind the counter warns clientele to tell "No War Tales – Obey the Law!" This warning was adopted to counteract the activities of German espionage agents during World War I.

THE FIFTH AVENUE HOTEL. The Fifth Avenue Hotel, located at Fifth Avenue and 23rd Street at Madison Square, was both luxurious and popular, and its reputation was enhanced by the fact that it was the first hotel in New York to provide an elevator for its guests. For years, "Boss" Thomas Platt, the leader of the New York State Republican Party, maintained his office in the building. The hotel was built by developer Amos Eno in 1856–1858. After 1890, Madison Square became less fashionable for the hotel trade as newer, grander establishments in midtown Manhattan displaced older ones like the Fifth Avenue. The hotel's end came in 1908 when it was closed and demolished.

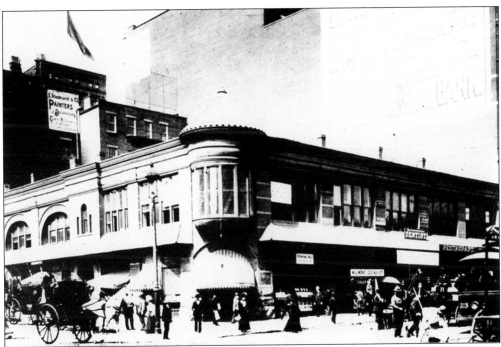

SCHOONMAKER'S DRUGSTORE IN THE 1890s. This popular drugstore was located at Park Avenue and 41st Street.

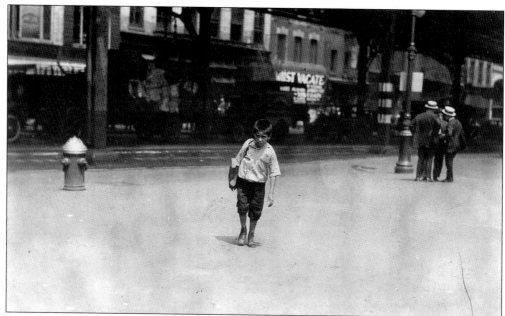

A Canal Street Bootblack. Jimmie was a seven-year-old bootblack and is seen working on Canal Street on July 25, 1924. (Library of Congress.)

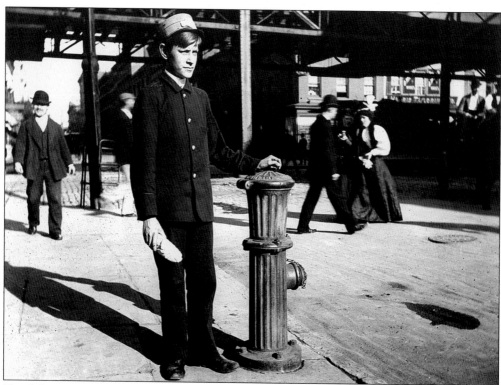

The Messenger Boy. Alice Austen took this photograph of a messenger boy with his hand reposing on a fire hydrant in 1896. Messenger boys were employed by all kinds of firms in those days. (Staten Island Historical Society.)

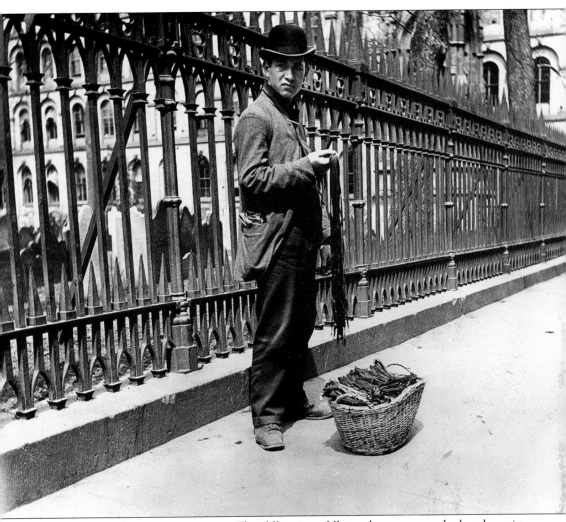

PEDDLING WARES ALONG BROADWAY. This fellow is peddling what appear to be bootlaces in front of Trinity Churchyard in lower Manhattan. (National Park Service.)

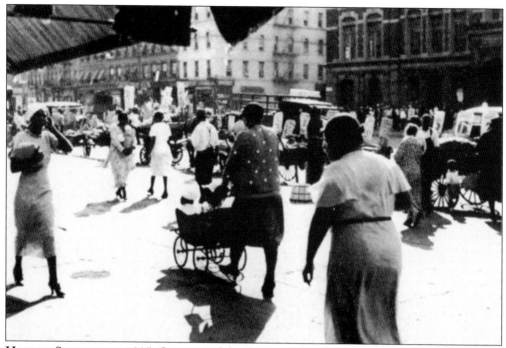

HARLEM SHOPPERS IN 1935. On a typical day, large numbers of women did their daily shopping from Manhattan street vendors. This picture shows such a scene at West 135th Street. (Library of Congress.)

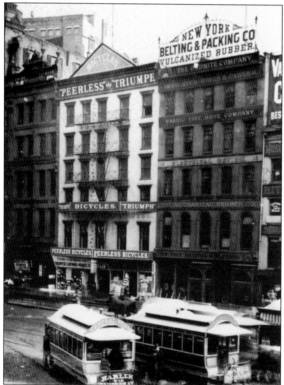

BUSINESSES ALONG PARK ROW. Dating from about the year 1896, this photograph shows a number of business concerns, including the Peerless and Triumph Bicycle Company, the New York Belting and Packing Company, and the offices of the Electrical Review. In the street are two Central Park trolleys bound for Harlem via Madison Avenue.

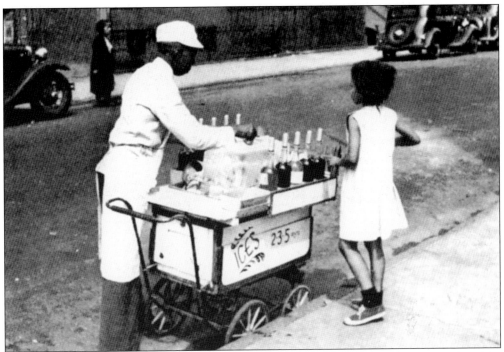

REFRESHMENT VENDOR. Fruit-flavored icicles were sold throughout the city in warm weather. Here a girl is buying an icicle from a vendor in Harlem around 1936. (Library of Congress.)

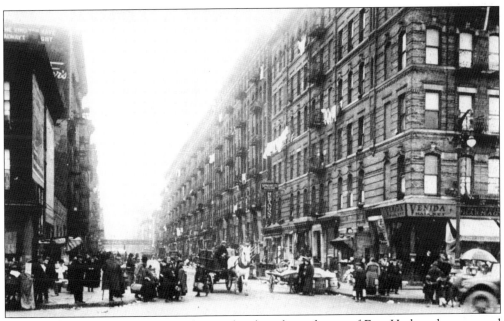

UPTOWN SHOPPERS. This picture shows a bustling, busy throng of East Harlem shoppers and pedestrians in 1917. As can be seen here, the community was predominantly populated by Italian immigrants and their children. Businesses in view include Palumbo's Pharmacy and a restaurant called the Spaghetti House. Today East Harlem is no longer Italian; it is now a Puerto Rican community known as Spanish Harlem or El Barrio.

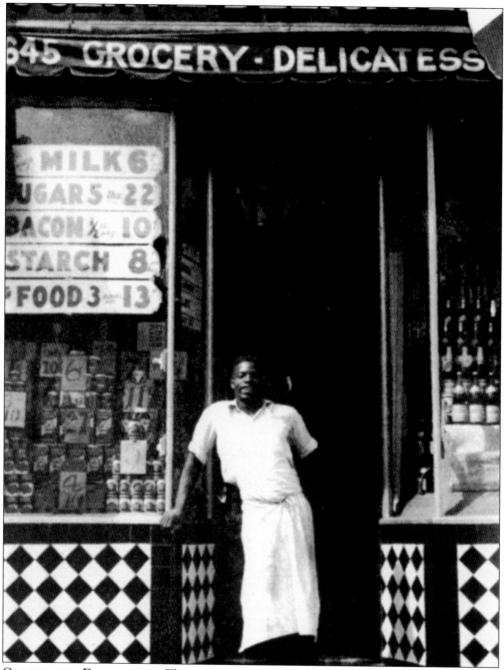

GROCERY AND DELICATESSEN. The prices in the window point to the late 1930s for this picture taken in Harlem. Prices such as 22¢ for a five-pound bag of sugar, three cans of dog food for 13¢, and a box of laundry starch for 8¢ were typical in that era. (Library of Congress.)

Three

TRAFFIC AND CROWDS

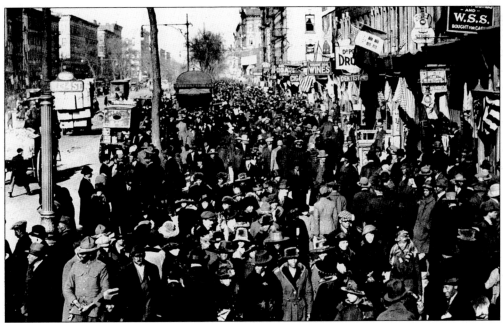

ARMISTICE DAY, 1919. On November 11, 1919, New Yorkers celebrated the first anniversary of the historic armistice that ended World War I. This picture was taken at West 134th Street and Lenox Avenue in Harlem. The war's end was quickly followed by the Roaring Twenties, a period of booming prosperity, Prohibition, and an outburst of creative activity in the arts, sciences, and technology. Only a few weeks after this picture was taken, the wine merchant on the right would no longer be able to conduct his trade due to National Prohibition.

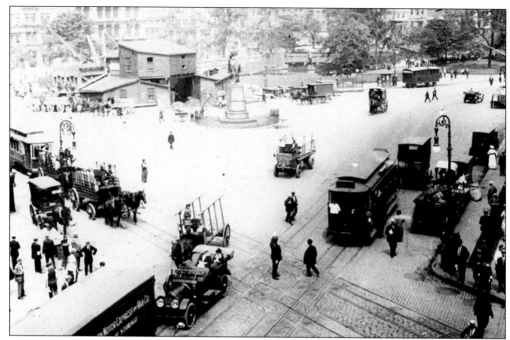

UNION SQUARE TRAFFIC. This picture of Union Square was taken around the year 1918. The square's famous statues, Henry Kirke Brown's *George Washington on Horseback* (1856) and Frédéric-Auguste Bartholdi's *Marquis de Lafayette* (1876), can be seen in the distance.

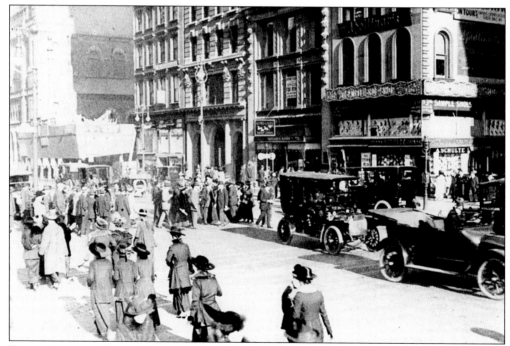

FIFTH AVENUE CROWD. This scene at Fifth Avenue and 42nd Street dates from 1918. Aside from the numerous office buildings, this area was noted for its smart shops and other mercantile establishments.

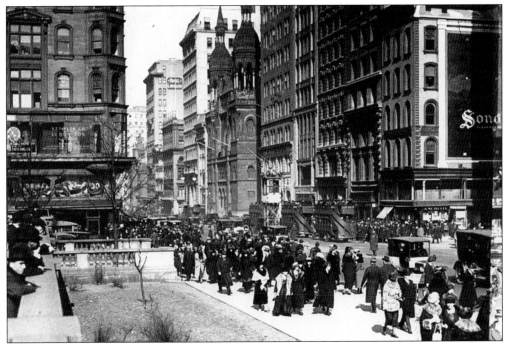

WALKING BY THE NEW YORK PUBLIC LIBRARY. Crowds gather at Fifth Avenue and 42nd Street in 1918. Not appearing in this picture is the building the pedestrians were passing by—the New York Public Library, which was to the left side of the lawn.

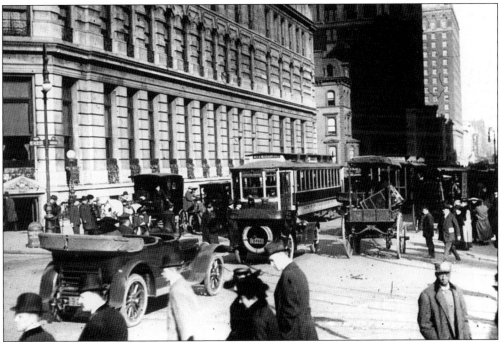

FORTY-SECOND STREET AND MADISON AVENUE. At the left is a portion of the elegant Hotel Manhattan. This picture is from about 1920.

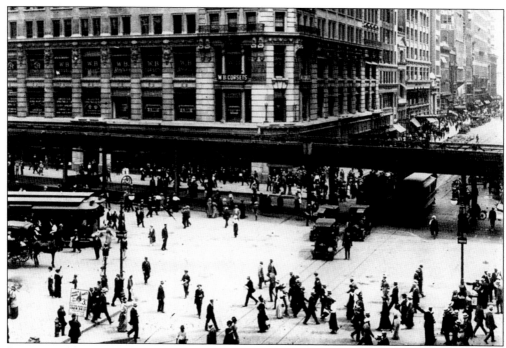

SHOPPING AND BUSINESS DISTRICTS. Above, W. B. Corsets are being offered in the large building opposite the elevated railway. Below is a similar business district scene.

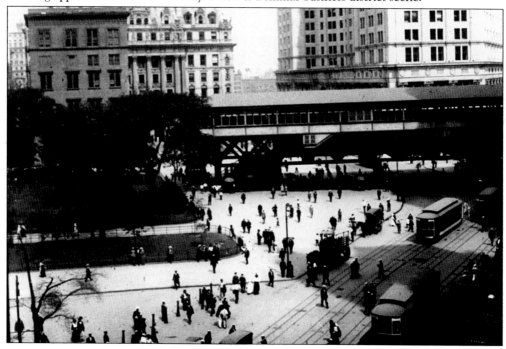

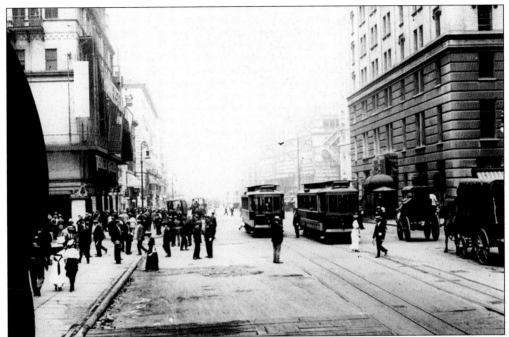

ALONG THE TROLLEY LINES. This image dates from the years immediately prior to World War I. Around this time, the price of a trolley ride was 5¢.

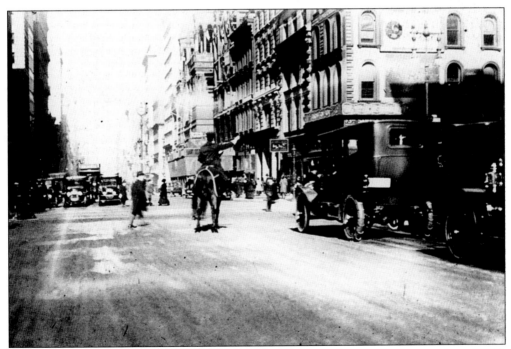

MOUNTED TRAFFIC POLICEMAN. The mounted officer is on duty at the intersection of Fifth Avenue and 42nd Street. Not surprisingly, mounted police have been a part of police work for well over two centuries.

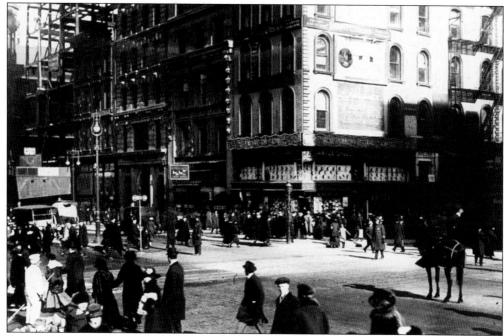

TRAFFIC POLICE. Two traffic policemen appear in this scene from Fifth Avenue and 42nd Street. The shops across the street are advertising the products of A. Schulte, while the billboard above urges people to buy Apollinaris mineral water.

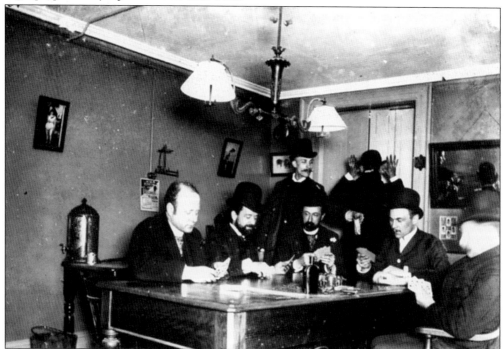

REPORTERS' OFFICE. Although taken indoors at their office at 301 Mulberry Street, these men spent much of their time looking for stories in the streets of Manhattan. The picture dates from around the 1890s and was taken by Jacob Riis.

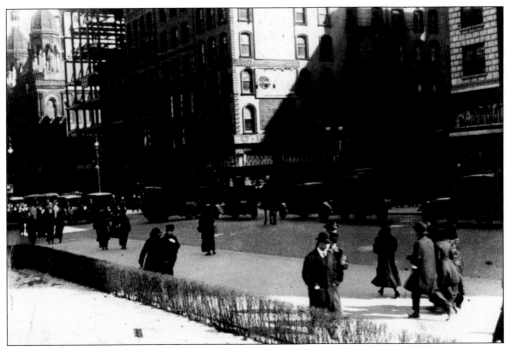

TWO VIEWS ALONG FIFTH AVENUE. Here are more scenes from Fifth Avenue and 42nd Street, but at different times of the year.

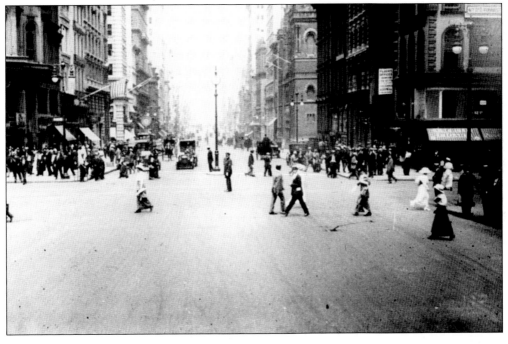

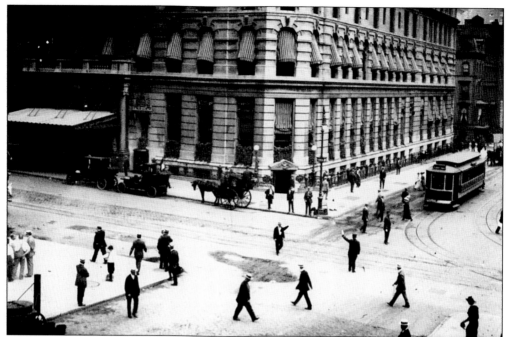

HOTEL MANHATTAN. Standing at the corner of Madison Avenue and 42nd Street, the Hotel Manhattan was a well-known stopping place for visitors. At the front entrance, three cabs wait to be summoned. The hotel was designed by Henry J. Hardenbergh and built in 1896–1897. It was within walking distance of Grand Central Terminal. In 1921, the hotel was remodeled for offices. It was demolished in the 1950s.

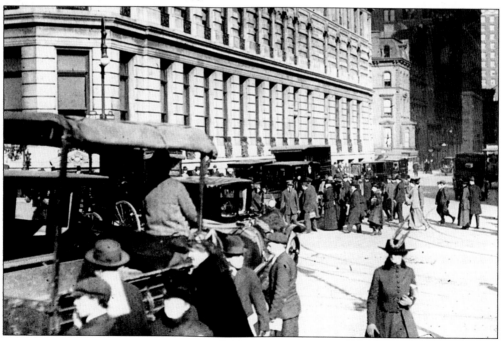

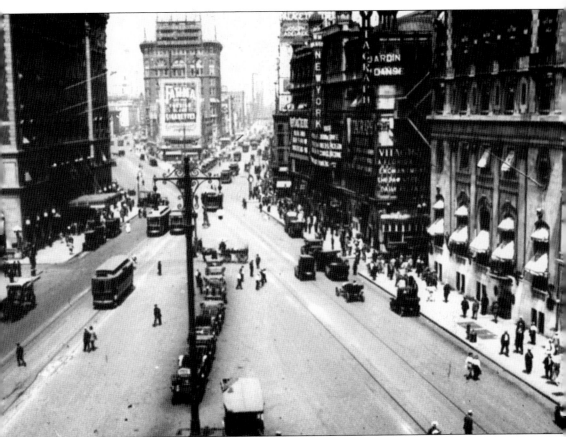

TIMES SQUARE, 1918. At the left stands the luxurious Hotel Astor. Various popular theaters are on the right, including the Vitagraph Theatre, the New York Theatre, and B. F. Keith's Palace Theatre. The legendary Palace Theatre was the place where the highest-paid vaudeville acts performed, such as the cyclonic Eva Tanguay (the "I Don't Care Girl"), comic juggler W. C. Fields, magician Harry Houdini, A. Robins (the musical clown), singers Nora Bayes (famous for "Shine on Harvest Moon"), Blanche Ring, Harry Richman, Arthur Tracy (with his accordion), and Van and Schenck, crooners Nick Lucas and Russ Columbo, witty monologist Frank Fay, dancers Eddie Foy, Ann Pennington, Pat Rooney, Joe Frisco, Fred Astaire, Clifton Webb, Mae Murray, Bill "Bojangles" Robinson, James Cagney, George Raft, and Charlotte Greenwood, female impersonators Bert Savoy and Julian Eltinge, as well as a crowd of comedians: Weber and Fields, Gallagher and Shean, Bert Williams, Eddie Cantor, Jimmy Savo, Jack Benny, Jimmy Durante, Clark and McCullough, Fred Allen, George Jessel, Smith and Dale, the Marx Brothers, Burns and Allen, Milton Berle, and Ted Healy and his (Three) Stooges.

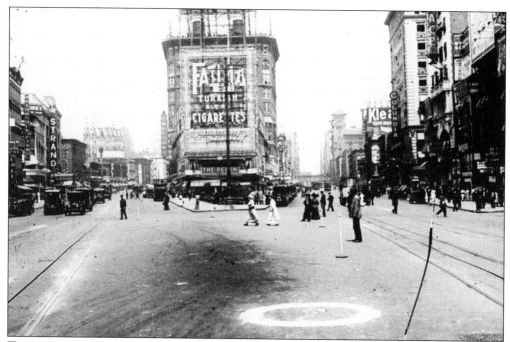

TIMES SQUARE CLOSE-UP. This closer view of the square in 1918 shows the advertisement for Fatima Turkish cigarettes, as well as the Strand Theatre to the left, a portion of the Palace Theatre to the right, and the showroom for purchasing Columbia phonographs and records.

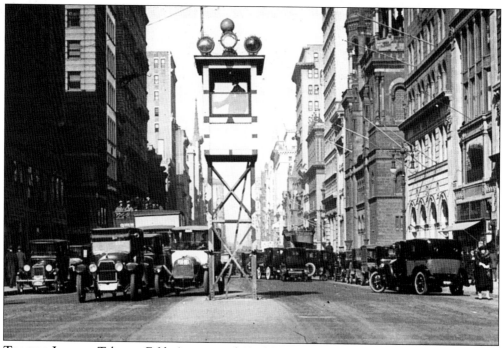

TRAFFIC LIGHTS. Taken at Fifth Avenue and 42nd Street around the year 1920, this shows one of Manhattan's earliest traffic lights. Note the very old Ford on the left.

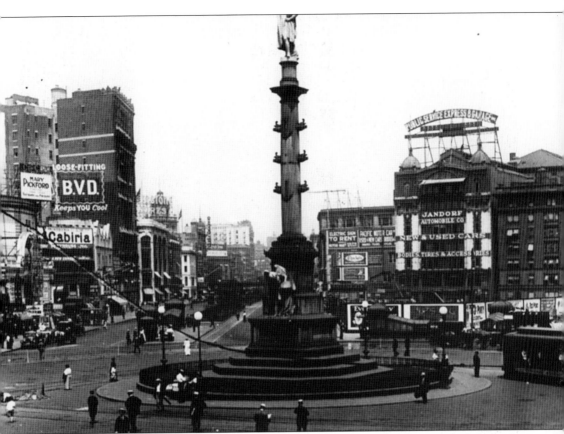

COLUMBUS CIRCLE. This was how Columbus Circle looked in the early 1920s. At the left, movie star Mary Pickford's latest film is being advertised in a huge white billboard at the Circle Theatre. Named in honor of the Italian explorer Christopher Columbus, who discovered the New World for the king and queen of Spain, Columbus Circle is a major commercial and entertainment district in Manhattan. It is also the location of several cultural and educational institutions.

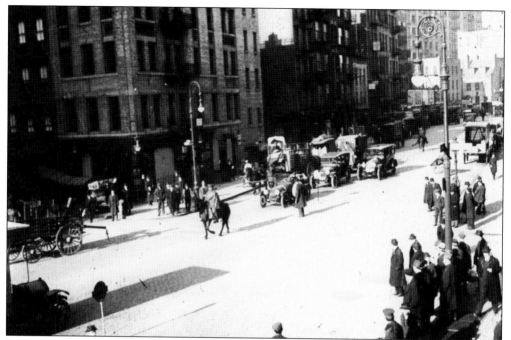

BUSY STREETS. This picture shows pedestrians waiting to cross the street. Note the lone horseman, lower left.

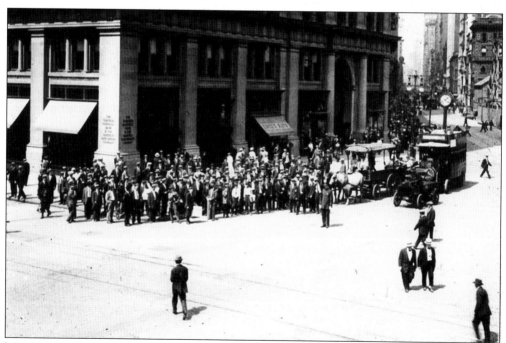

MADISON SQUARE TRAFFIC. This picture was taken at Madison Square.

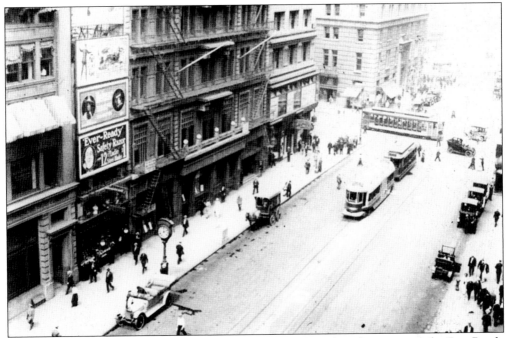

TROLLEYS. Trolleys trundle down a Manhattan street. Note the advertisement for Ever-Ready batteries on the left.

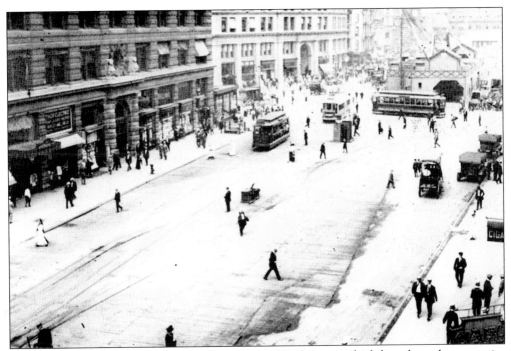

TRAFFIC AT 23RD STREET. This is a photograph of 23rd Street, which has always been a major thoroughfare. Theaters, shops, and offices are common destinations in the area. The YMCA and the Leo House for German Catholic immigrants have had a presence there for decades.

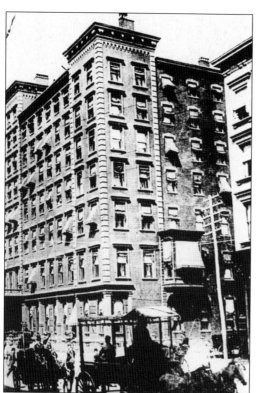

Horse Traffic around 1900. In front of this building, probably an apartment house or a hotel, a horse carriage and horse-drawn wagons pass by.

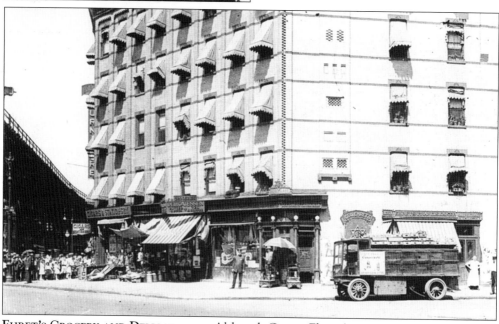

Ehret's Grocery and Delicatessen. Although George Ehret (1835–1927) sold a wide range of items such as groceries and tobacco, he was really more famous for his brewery. Ehret came to America from Germany in 1857 and, with his father, operated the Hell's Gate Brewery. Following his death in 1927, his family sold out to another German, Col. Jacob Ruppert. At his death, Ehret left a $40 million estate.

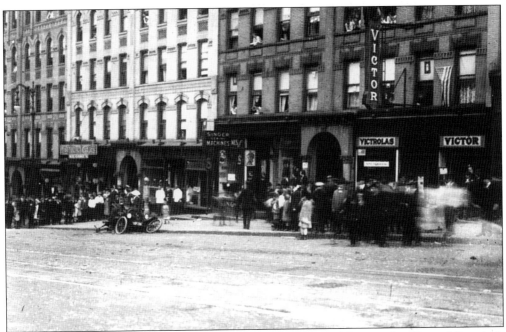

VICTOR TALKING MACHINES. An accident occurred in front of this merchandiser of America's most popular phonograph machine, the Victrola. Victrolas played the records of some of the Victor Talking Machine Company's greatest stars, including Enrico Caruso, the Paul Whiteman Orchestra, and Al Jolson. Aside from small shops like the one pictured here in 1918, Victrolas were also sold at grand department stores like R. H. Macy's and Gimbel's.

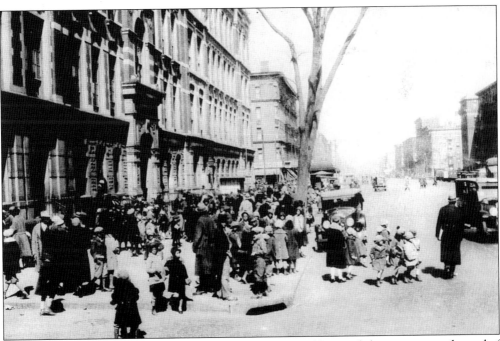

AN ELEMENTARY SCHOOL IN HARLEM. This picture of children and their parents at the end of the school day was taken in 1927.

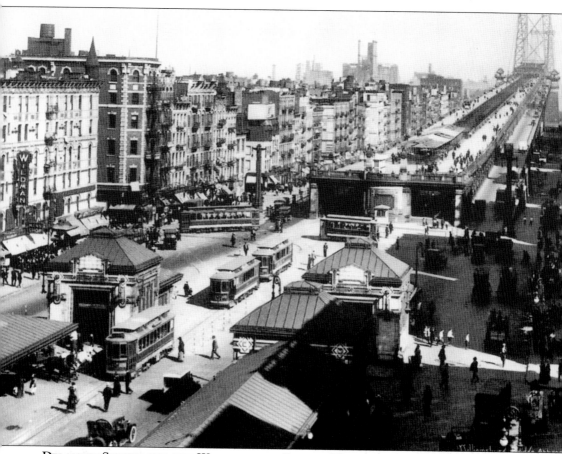

DELANCEY STREET AND THE WILLIAMSBURG BRIDGE. This photograph of the Lower East Side was taken around 1920. The Williamsburg Bridge, shown on the upper right, is a steel suspension bridge that spans the East River. It was constructed in 1902.

Four

VARIOUS MOTOR VEHICLES

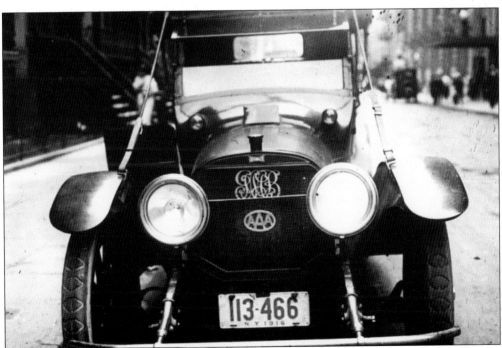

A 1916 CHANDLER. One of the latest motorcars of the day, this 1916 Chandler served the American middle class's growing demand for cars. Chandlers, which were popular in the Roaring Twenties, were produced from 1913 until the company was merged with another automobile manufacturer in 1929. After the merger, Chandlers disappeared from the market.

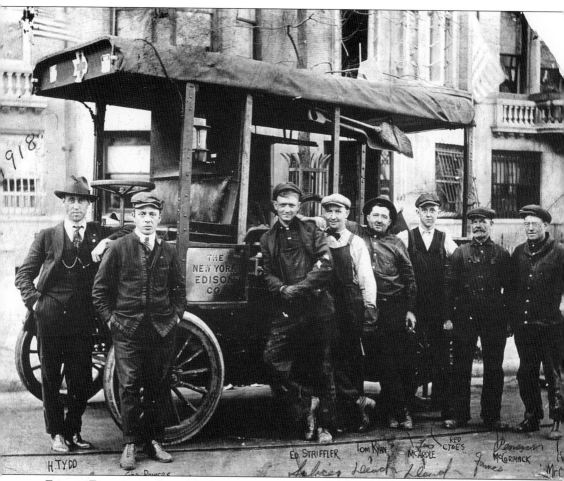

EDISON EMPLOYEES. For many years, Thomas Alva Edison's New York Edison Company was a flourishing electrical concern in Manhattan. Pictured in this photograph from 1918 are a few of the Wizard of Menlo Park's workmen. From left to right are H. Tydd, George Powers, Ed Striffler, Tom Ryan, Leo McArdle, Red Ctoes (?), R. McCormack, and ? O'Dwyer.

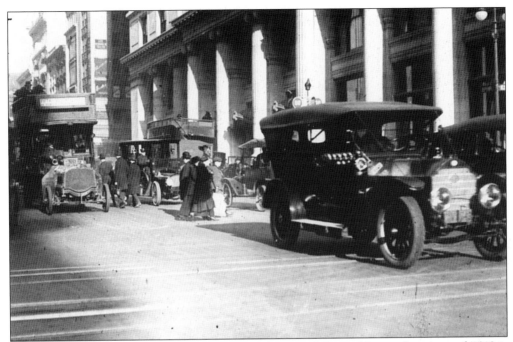

TRAFFIC ON THE AVENUE. A close-up of typical automobiles and busses from around 1918 is shown here. Bus 7657 was on the Fifth Avenue–Seventh Avenue line.

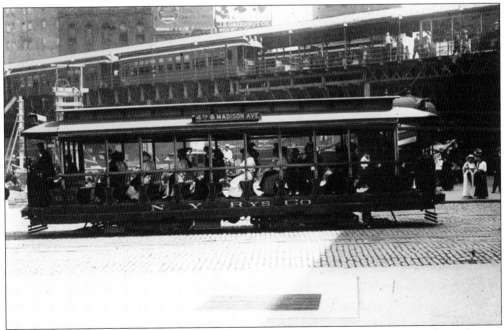

A TROLLEY AND AN ELEVATED TRAIN. This picture shows two possible ways of traveling in Manhattan around the year 1910: on board a New York Railways Company trolley or on an elevated train.

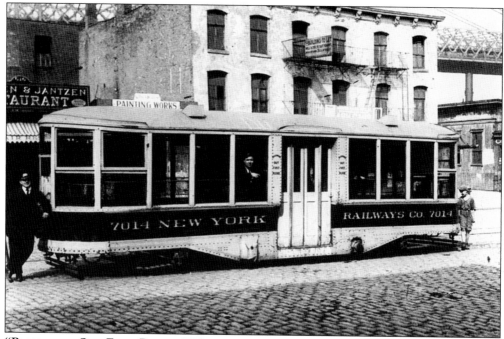

"PASSENGERS OUT FIRST PLEASE." This instruction is painted at either side of the trolley doors. This picture was taken in the Lower East Side.

DOWNTOWN SIDE STREET. A child plays on someone's car. This photograph was taken not very far away from Centre Street in the lower reaches of Manhattan.

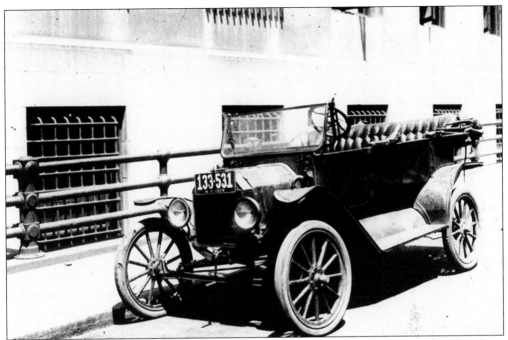

ANOTHER AUTOMOBILE. Parked in the same street, this vehicle bears a license plate that dates from 1917.

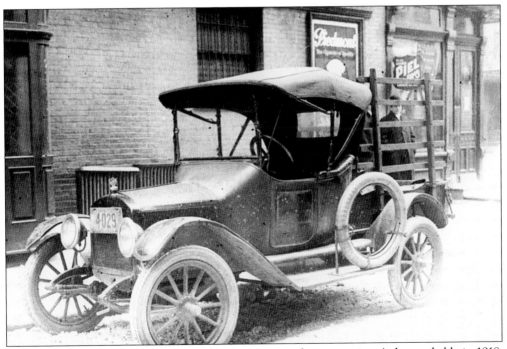

FORD ROADSTER WITH SPARE TIRE. This picture was taken on a winter's day, probably in 1918. Advertisements for a Piedmont product and Piel's beer are posted nearby.

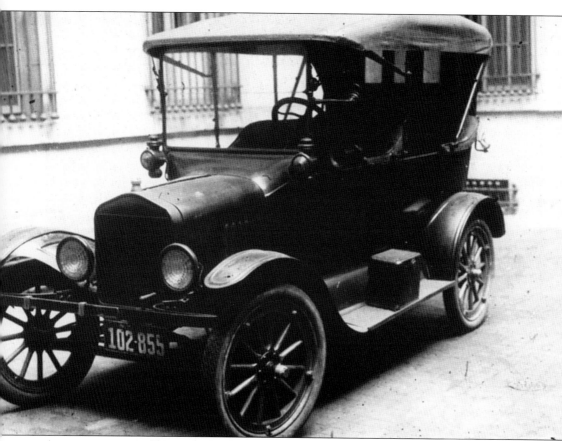

AUTOMOBILE WITH TOOLBOX. Some motorcars from the 1918 period, such as this Ford touring car, had toolboxes attached to the running board. Note also the hooter (horn).

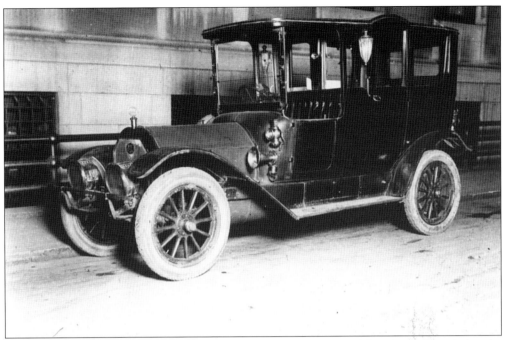

An Early Limousine. This motorcar was a more expensive model and was intended to be driven by a chauffeur. Note its lamp and horns.

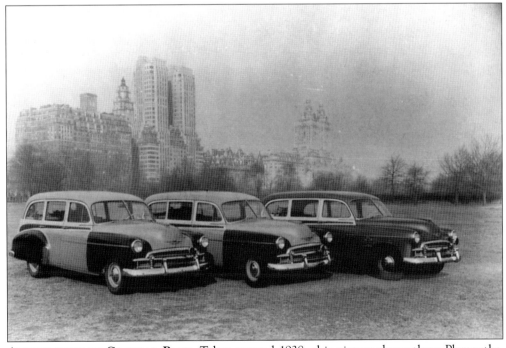

Automobiles in Central Park. Taken around 1938, this picture shows three Plymouths. The view of the buildings indicates that the cameraman was facing the Upper West Side of Manhattan when he took this picture.

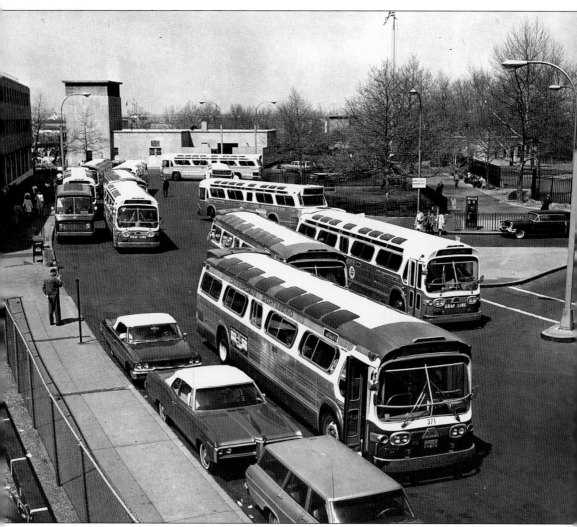

BUSSES AT THE BATTERY. Tourism to Manhattan boomed in the years that followed the end of World War II. One of the most popular must-see sites is the Statue of Liberty. Here several tourist busses and their drivers wait for the return of their passengers who have gone to Liberty Island. On the left (near the mailbox) is the Coast Guard's Marine Inspection Office building, and to the right is Battery Park.

Five

THE POLICE FORCE

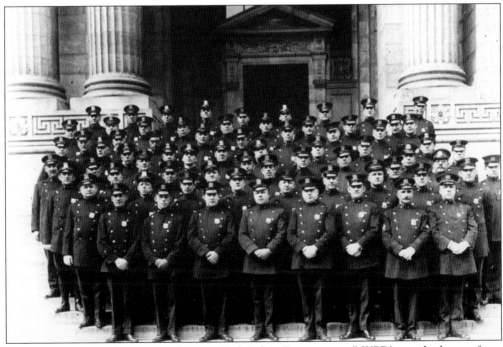

NEW YORK POLICE OFFICERS. The New York Police Department (NYPD) was the largest force in the country, and other big-city departments patterned many of their investigative procedures on its detective force.

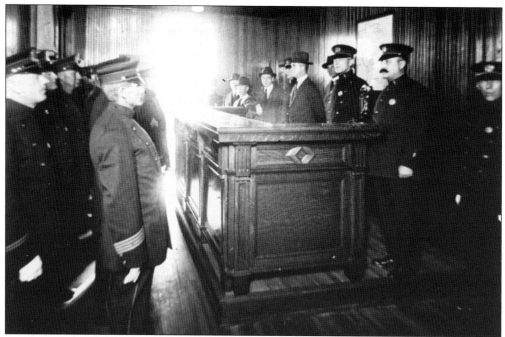

AN OFFICIAL VISIT TO A POLICE STATION. The police commissioner and senior police officials are on an official visit to a police station in this c. 1918 photograph.

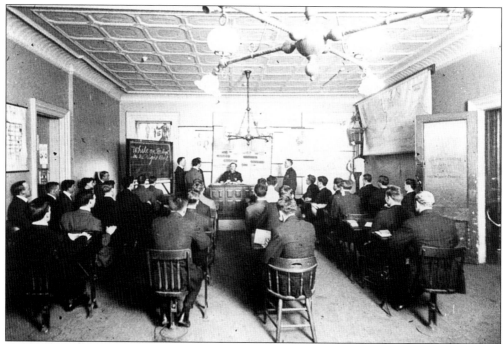

TRAINING NYPD RECRUITS. This class for training new policemen was photographed in 1912. The instruction for night patrol is still visible on the blackboard.

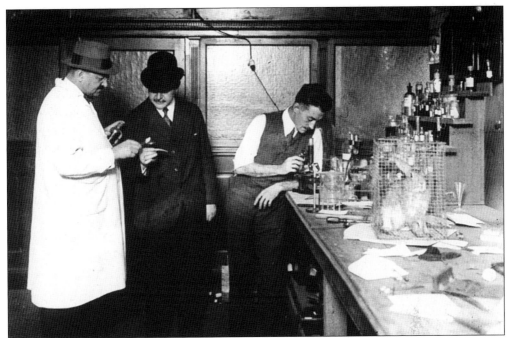

THE CRIME LABORATORY. The value of scrutinizing evidence with the aid of science has been an important part of police operations from even the earliest years of the 20th century. In this photograph of an NYPD crime laboratory, the caged rabbit and the array of chemicals in bottles attract immediate attention.

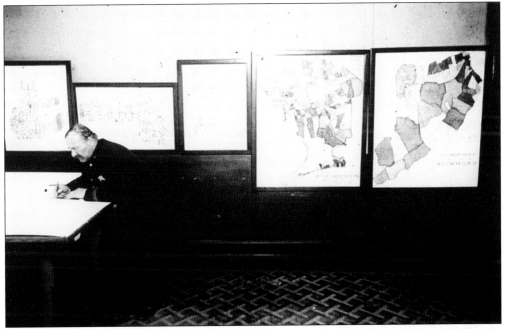

THE MAP ROOM. Following the enlargement of New York City in 1898, in which Manhattan was joined by the outlying areas of Brooklyn, Staten Island, the Bronx, and Queens, the police also needed to increase both the size of its force and the range of its activities and outlook.

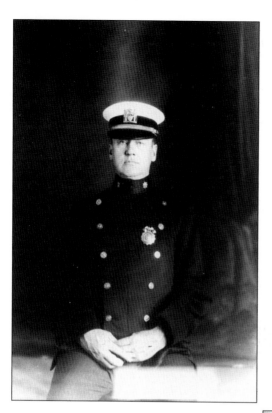

A POLICE LIEUTENANT. Honor, duty, trustworthiness, and courage were expected of all policemen, and lieutenants, such as this man, were among the officers expected to demonstrate these virtues at all times.

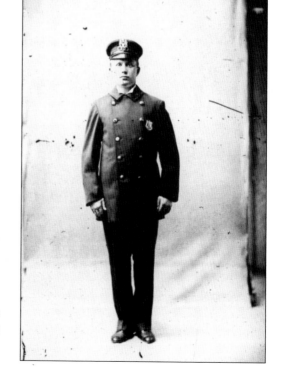

A YOUNG PATROLMAN. This 1920s police officer was among the many young men who probably joined the force as a career. During that decade, the police force rose from 10,000 officers in 1920 to 18,000 in 1929.

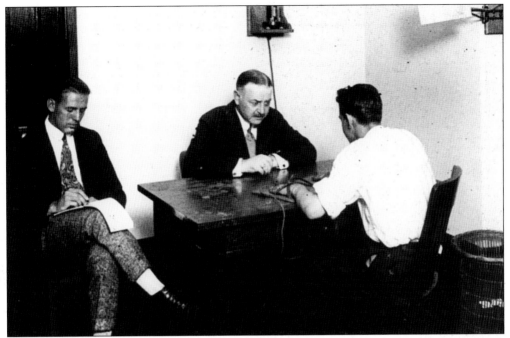

THE POLYGRAPH TEST OR "LIE DETECTOR." This suspect is undergoing one of the latest technological advances of the period, a lie detection test. Despite its fame, the lie detector was soon proved not altogether reliable.

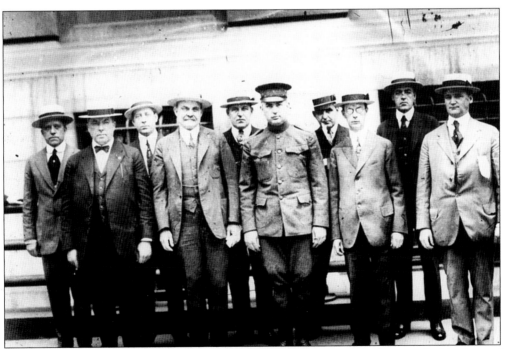

NEW YORK POLICE DETECTIVES. These 1920s NYPD detectives were photographed in front of police headquarters in Centre Street.

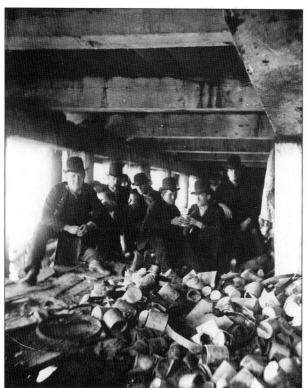

THE SHORT TAIL GANG.
Crime lurked in many places in
Manhattan. This 1889 picture
shows members of the notorious
Short Tail Gang in one of their
hideouts (at Corlears' Hook).
Thugs such as these plagued
the city slums and gave the
police much trouble. (Jacob Riis
photograph, Museum of the City
of New York.)

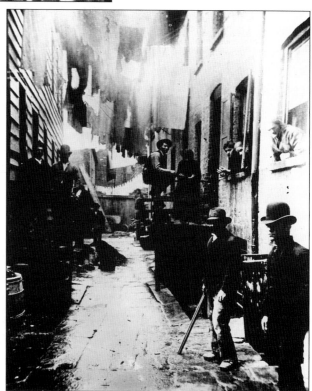

BANDIT'S ROOST. Jacob Riis took
this now classic crime picture
about the year 1888. The picture
was at 39½ Mulberry Street, which
is now a part of Chinatown.

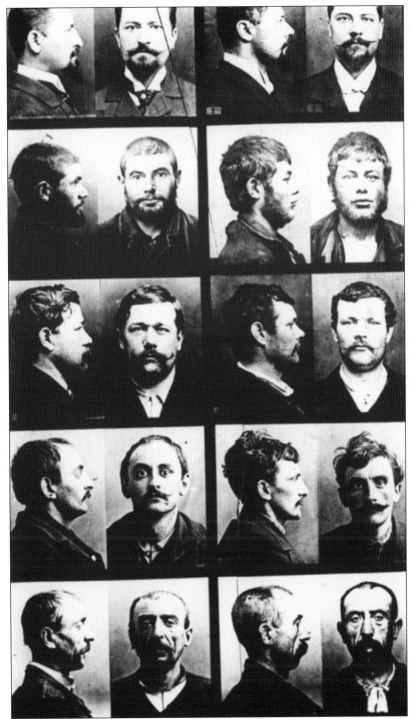

MUG SHOTS. The NYPD kept vast files on criminals. This selection of criminal mug shots shows five rows of pictures of five known criminals. Photography had been introduced in the 19th century, and the police soon adopted a policy of photographing within a few hours all persons that had been placed under arrest.

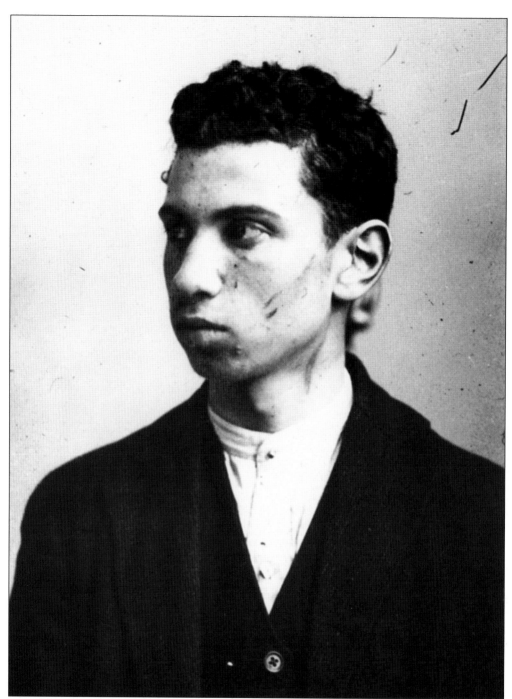

MUG SHOT OF A DELINQUENT. The invention of photography was a major advance in crime detection. Poverty and lack of education and care often explained the great number of young delinquents that roamed the streets of the city in the early years of the 20th century. Many were foreign born and had emigrated from Europe. Among them were these future gangsters: Owen "Owney" Madden (Irish), Charles "Lucky" Luciano (Italian), and Meyer Lansky (Jewish). Each of these men had entered the country through Ellis Island.

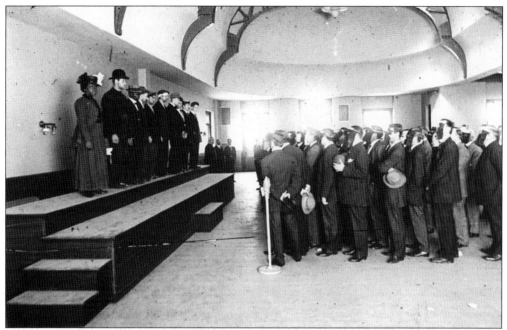

IDENTITY PARADE OR "THE LINEUP." In the tradition of London's Scotland Yard, the NYPD carried out identification parades of suspects and innocent civilians. Note that the men gathered to select a criminal wear black masks over their faces as a means of not being identified themselves.

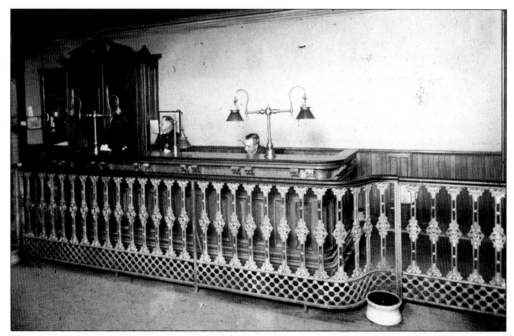

THE STATION HOUSE DESK SERGEANT. This was the common way police station lobbies looked in the old days. Uniformed officials (or servants) called doormen aided the regular desk sergeants and other policemen assigned to man the desk.

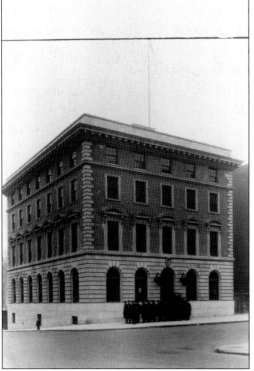

POLICE STATION. The police officers are lined up outside of their precinct station house in the 1920s.

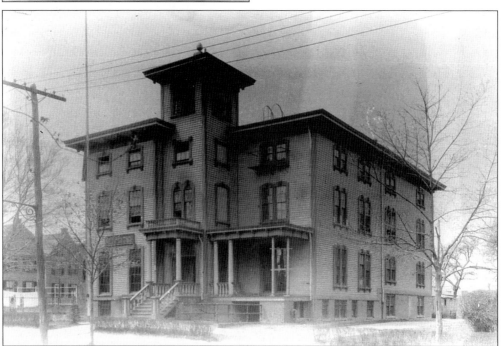

POLICE STATION IN WINTER. Police stations in New York were usually not constructed for the purpose but were merely purchased as the need arose. A good example of this is this police station, which once upon a time might have been a private house.

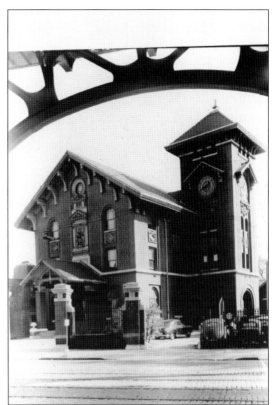

THE 52ND PRECINCT. This precinct station house was located at Webster Avenue in the Bronx. Until 1906, it was known as the 41st precinct. The architectural firm of Stoughton and Stoughton designed it.

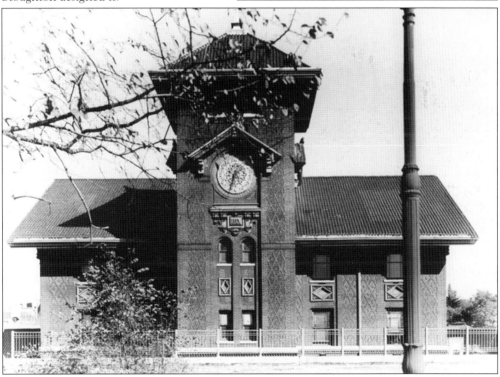

STATION HOUSES. Here are two other police buildings, both of which are attractive yet exhibit striking dissimilarities of style.

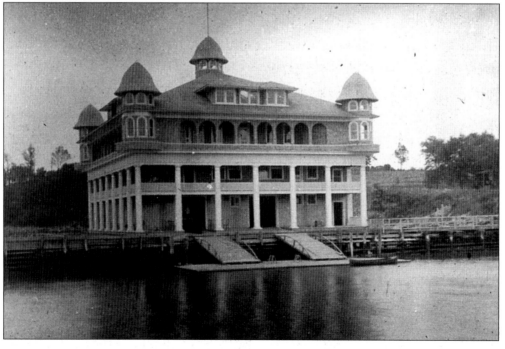

60

MORE POLICE STATIONS. The demand for a greater number of policemen during the 1920s and 1930s, a period when criminal activities had increased enormously, also required the purchase and construction of more station houses. Unlike many of the earlier structures, the building on the right was planned and constructed as a police station.

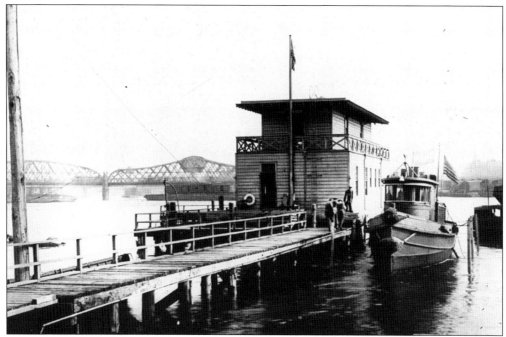

NEW YORK HARBOR POLICE. This was one of several boats operated by the harbor police. During the Roaring Twenties, the harbor police had its hands filled with rumrunners and retrieving the corpses of murder victims who had been dropped into the waters by gangsters and other hoodlums.

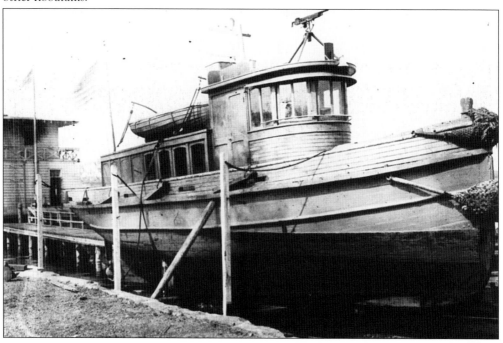

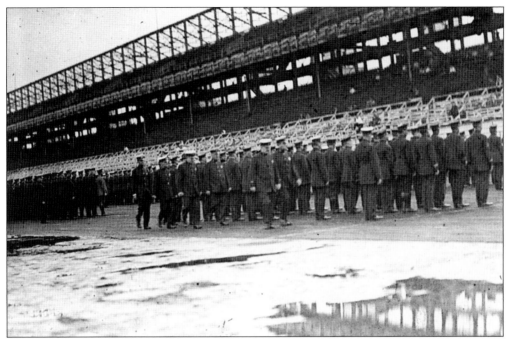

POLICE EVENT AND POLICE CAMP. These pictures show two of the outdoor events that the police engaged in during the 1918–1920s period.

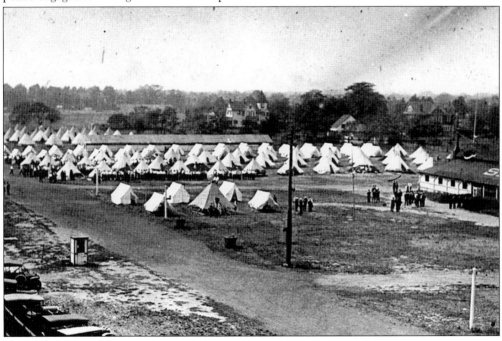

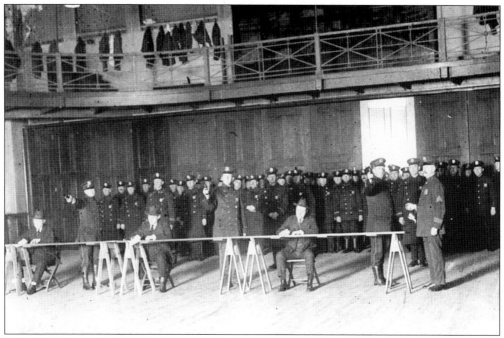

POLICE ASSEMBLY. This picture was taken inside of one of the police buildings. The police always would muster for deployment on major public occasions such as political conventions, parades, and demonstrations.

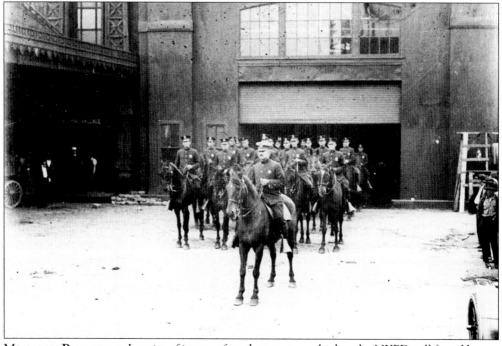

MOUNTED POLICEMEN. In spite of its use of modern motor vehicles, the NYPD still found horses useful in its work.

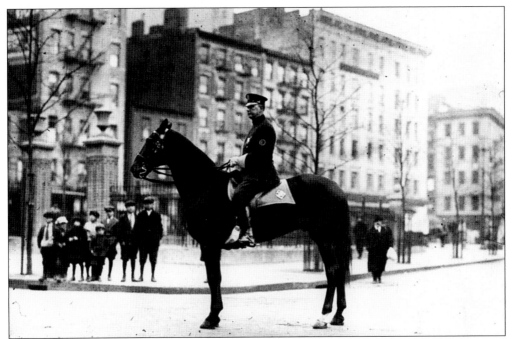

HORSE PATROLS. Mounted officers patrolled many parts of Manhattan, including Central Park (below).

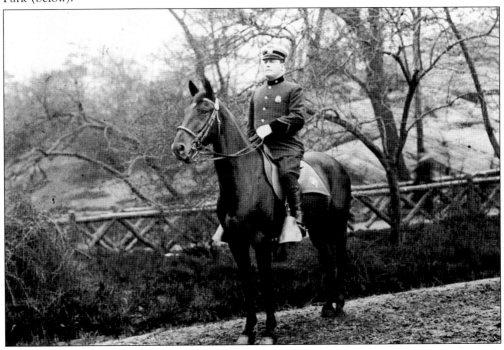

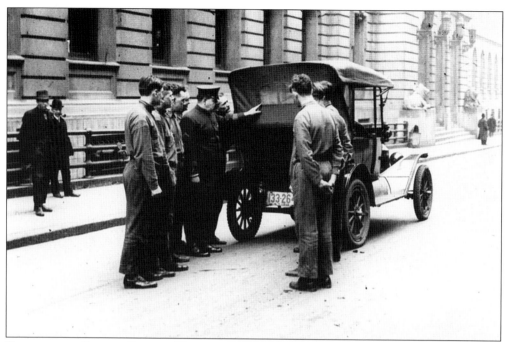

TRAINING IN CENTRE STREET. These young men are taking instructions from a police officer about motorcar identifications in front of police headquarters in Centre Street, lower Manhattan. The year is about 1920, and the car they are inspecting is a 1918 Ford Run-a-Bout.

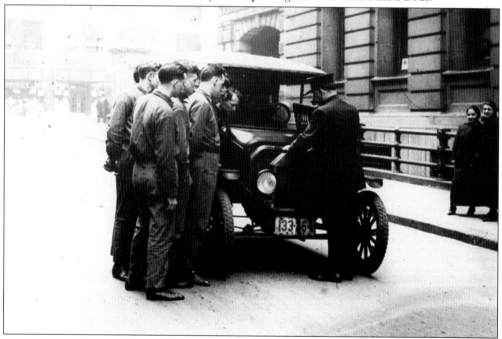

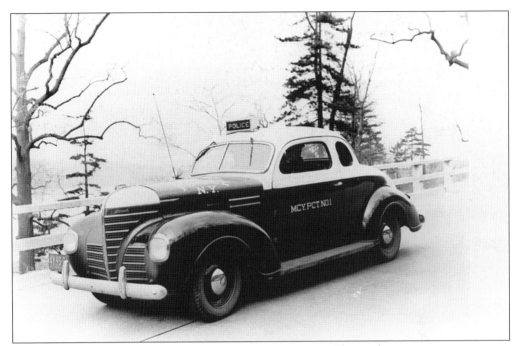

POLICE CAR, 1930s. This police car from Precinct No. 1 is a Plymouth.

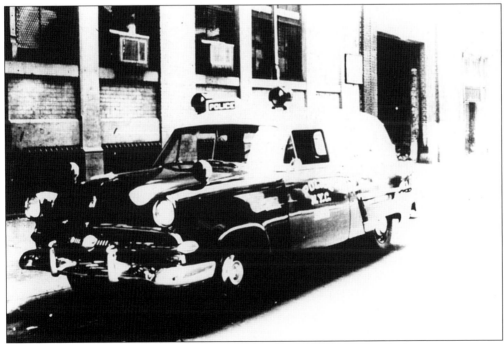

POLICE CAR, 1940s. For many years, Plymouths were standard NYPD vehicles.

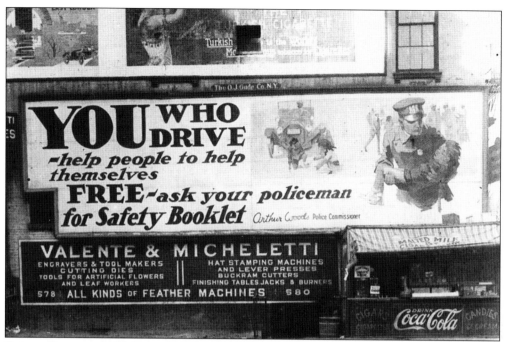

POLICE BILLBOARD NOTICE. Police commissioner Arthur Woods put up these notices to promote the department's safety booklet. The advertisement below was posted at Fifth Avenue and 42nd Street.

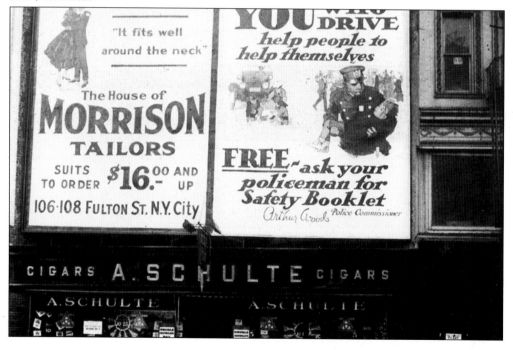

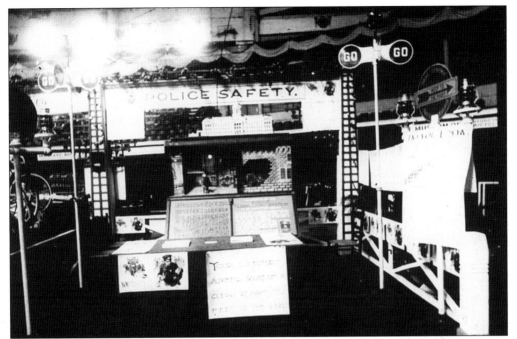

SAFE DRIVING EXHIBIT. This traffic safety exhibit was open to the public and provided valuable information on police policy, especially in respect to traffic and motoring. Among the exhibits here, one explains the requirement for license plates on cars to be visible within a distance of 50 feet, and another explains the police flashlight system.

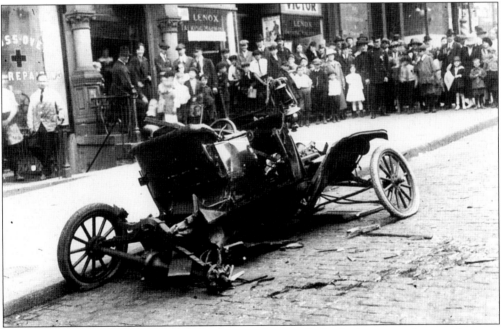

SMASHED CAR. This picture of a smashed car and a crowd of onlookers was taken on the same day and near the same phonograph shop selling Victor talking machines (Victrolas) as shown on page 39.

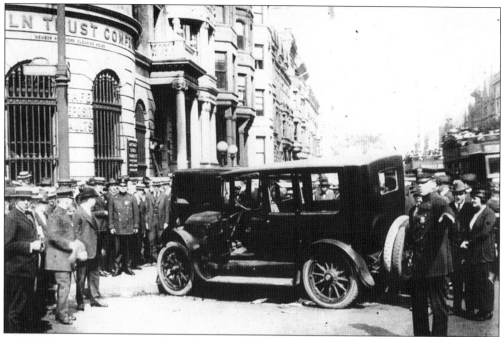

AUTOMOBILE ACCIDENTS. As can be seen here, three cars had been smashed up when these pictures were taken. The accident shown in the photograph below took place at West 72nd Street.

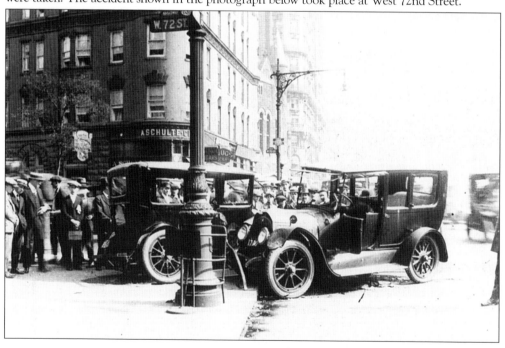

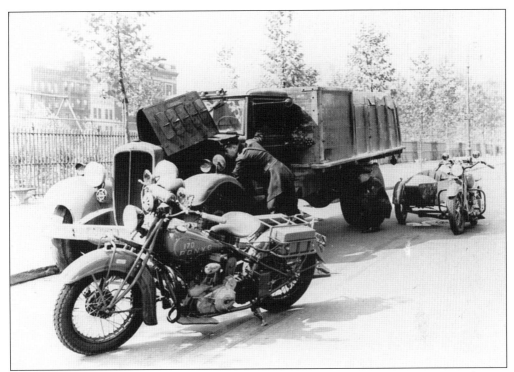

MOTORCYCLE POLICE. A motorcycle policeman examines the motor of a truck around 1940. The motorcycle is a 1938 or 1939 Indian Scout.

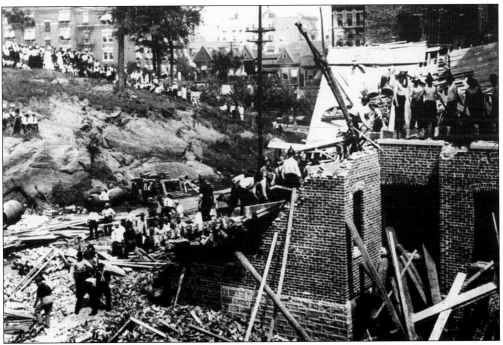

THE NEW YORK FIRE DEPARTMENT AND SAFETY. Firemen work on a hazardous structure in the 1920s.

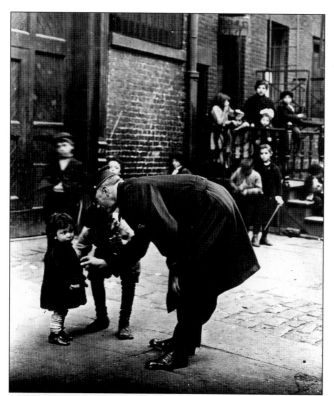

TEACHING SCHOOLCHILDREN.
City police officers regularly
provided safety instructions
to schoolchildren. The danger
of motor vehicles and traffic
were major problems in the
early days of motoring. The
traffic officers and patrolmen
on the beat came to know the
schools, teachers, children, and
residents of the neighborhood
to which they were assigned.

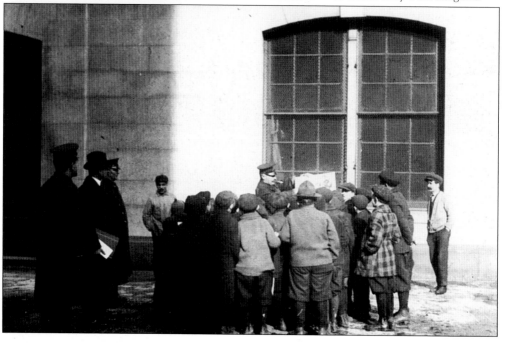

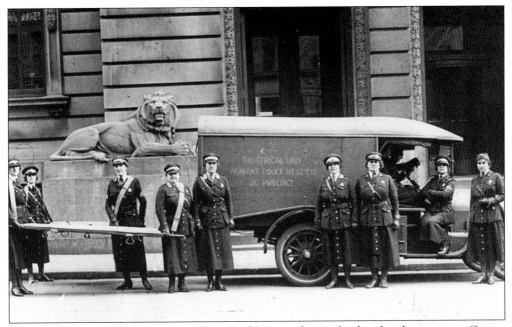

New York City's Women Police. Pictured here in front of police headquarters on Centre Street are members of the Women's Police Reserve's Theatrical Unit. The policewomen are showing how one of their stretchers was used. Their task was to secure women who had been arrested in theater raids. Theaters presenting plays or performances deemed immoral were commonly raided during the Roaring Twenties. In 1926, actress Mae West was arrested for an off-color play and then imprisoned at Welfare Island.

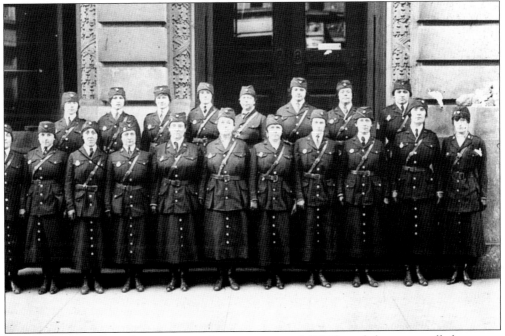

Policewomen. The earliest women police were engaged (1891), and they were called matrons and took care of female detainees. In 1918, the NYPD hired its first policewomen.

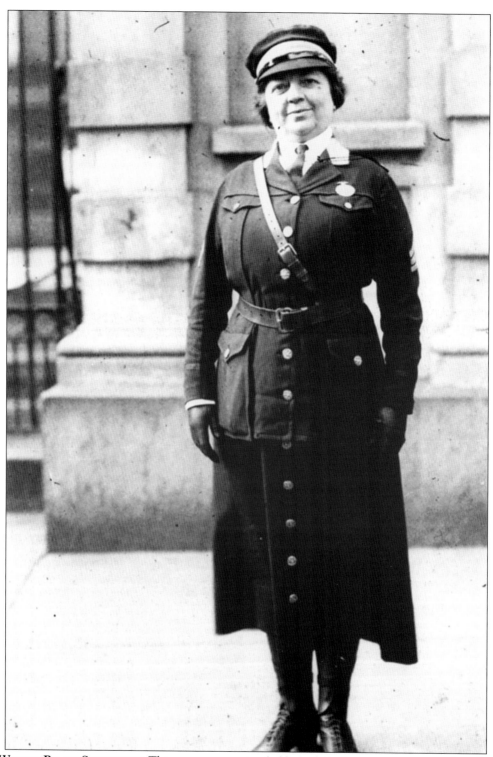

WOMAN POLICE SUPERVISOR. This woman supervisor held a rank similar to an army corporal; in this way, although senior to the other women, she still was of a lesser rank than a male police sergeant.

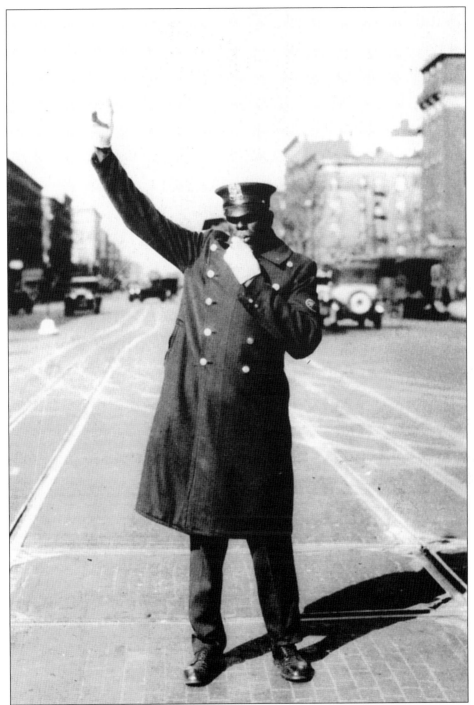

TRAFFIC POLICEMAN. African American policemen were usually assigned to black neighborhoods such as Harlem. This ethnic policy in policing was applied to all major ethnic communities. For instance, Italian American policemen worked in Little Italy and East Harlem, and Jewish American officers patrolled the Jewish Lower East Side. This photograph was taken at 135th Street and Lenox Avenue in 1927.

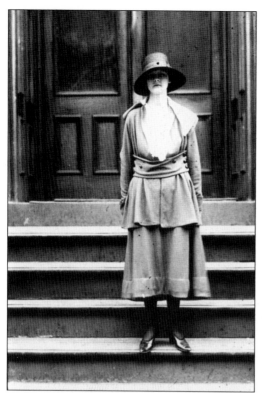

Two Policewomen. On the left is probably an undercover policewoman, and below is an equestrian policewoman.

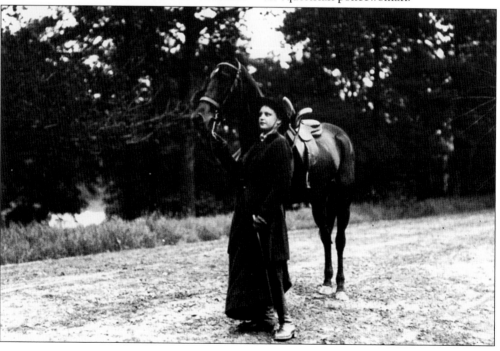

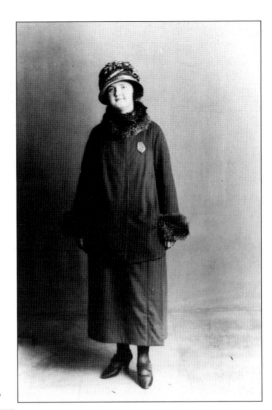

POLICEWOMEN AND FASHION. Although wearing badges, these two policewomen of the 1920s are dressed in "plain street clothes."

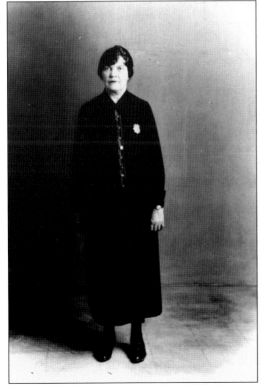

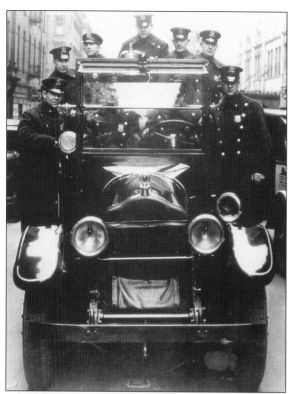

NEW NYPD PATROL CAR. This group of policemen shows off a new Buick patrol car in 1926.

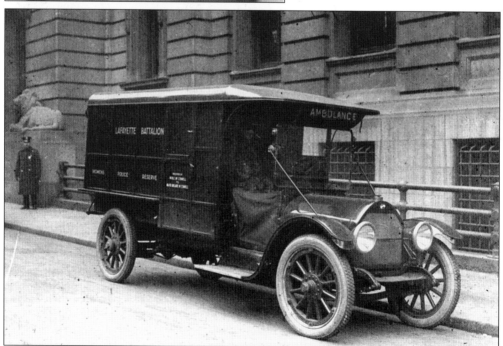

WOMEN'S POLICE PADDY WAGON OF THE 1920S. Standing in front of police headquarters downtown is an ambulance that was assigned to the Women's Police Reserve of the Lafayette Battalion.

Six

THE FOREIGN ELEMENT

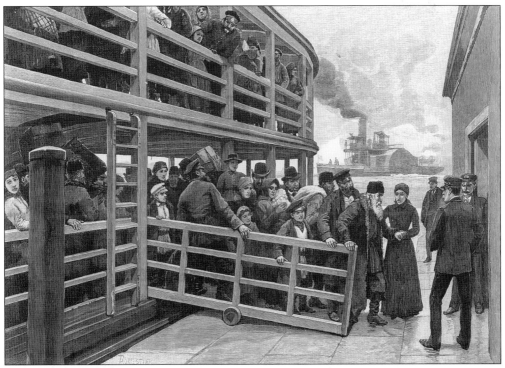

IMMIGRANTS LANDING IN MANHATTAN. Here Russian Jews just released from Ellis Island are seen landing from a boat at the Barge Office in the 1890s. Since the 1840s, New York City has been the country's most ethnic big city in terms of immigrant diversity. Various foreign colonies emerged, including Kleindeutschland, Little Ireland, Little Italy, the Jewish Lower East Side, Little Syria, Chinatown, and other enclaves of Poles, Greeks, Ukrainians, Czechs, Serbs, Croats, Hungarians, West Indian blacks, French, Welsh, Spaniards, and Scandinavians.

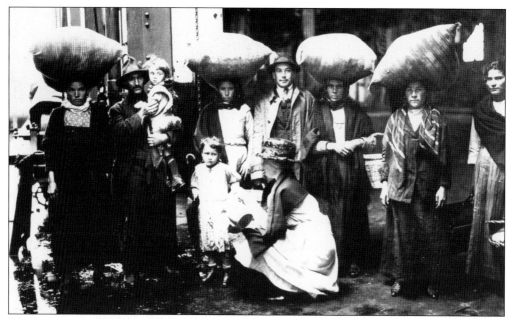

HELP FROM THE RED CROSS. In this picture, a social worker from the American Red Cross distributes milk to newly arrived European immigrants at the dock in this picture. The picture probably dates from around 1914 to 1924, the period in which the Red Cross increased its activities for immigrants and immigrant refugees at Ellis Island. The immigrants pictured here are probably from Italy or one of the Balkan kingdoms.

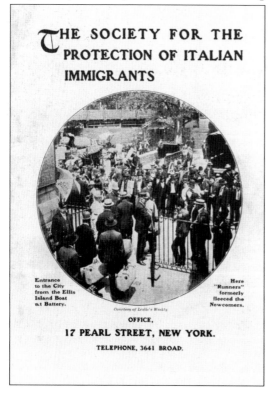

ITALIAN IMMIGRANT AID. Newly landed immigrants are seen here exiting the gate from the Ellis Island ferry. Wagons and horses as well as friends and relations await them in Battery Park. The Society for the Protection of Italian Immigrants sent agents to help detained Italian immigrants on Ellis Island. As advertised here, the society maintained its office at 17 Pearl Street, Manhattan.

80

THE JEWISH LOWER EAST SIDE.
Here is how Hester Street appeared
in the days when it still played a
leading role in the lives of Jews
from eastern Europe. After being
released from the Ellis Island
Immigrant Station, hundreds of
thousands of Jews settled here. A
mixture of Ashkenazi, Sephardic,
and other Jewish cultural traditions
thrived here for decades.

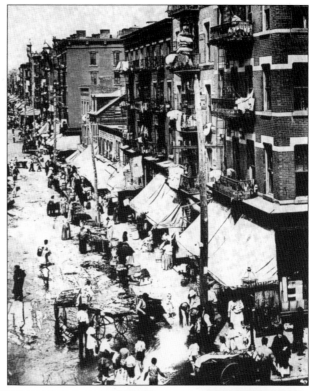

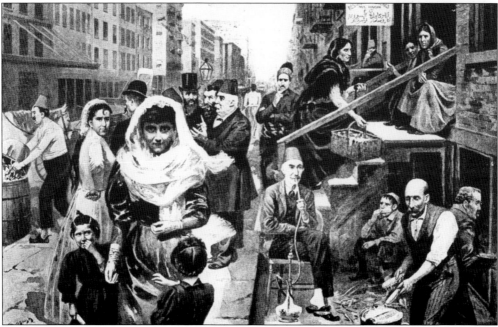

LITTLE SYRIA. Immigrants from the Arab world, mostly Lebanese and Syrian Christians, settled in Manhattan's Lower West Side. This sketch shows daily life in their main thoroughfare, Washington Street. Like the European immigrants, they had also entered the country through Ellis Island. (National Park Service.)

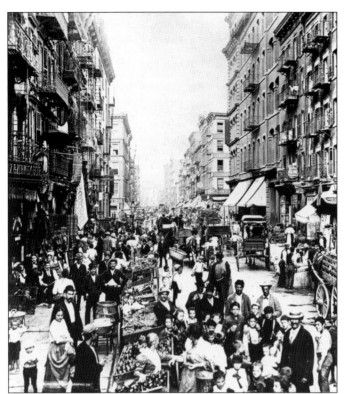

LITTLE ITALY. Jacob Riis took this classic scene of life in Little Italy's Mulberry Street in 1900. Located in the Lower East Side, this Little Italy was the largest of its kind in North America.

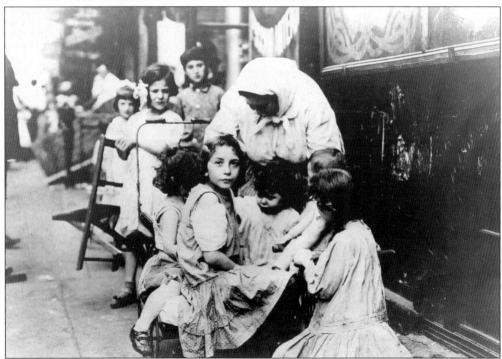

AN ETHNIC NEIGHBORHOOD. An immigrant mother attends her children. (National Park Service.)

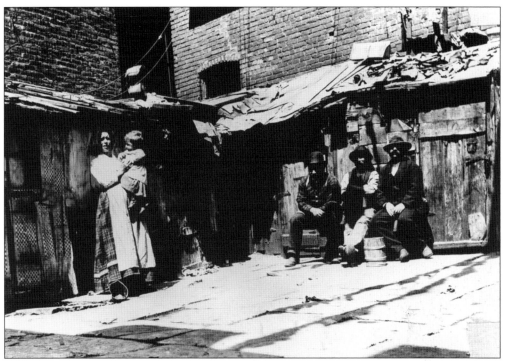

TENEMENT HOUSING. The poor condition of many of the city's tenement houses provided classic images of early-20th-century slum life in New York.

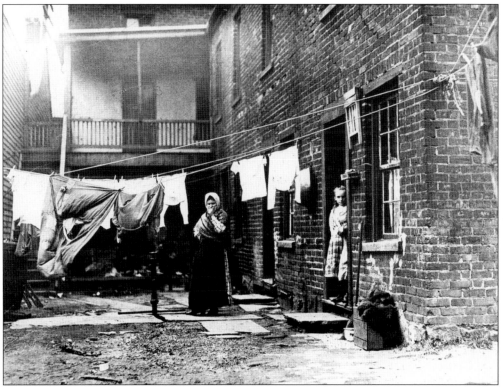

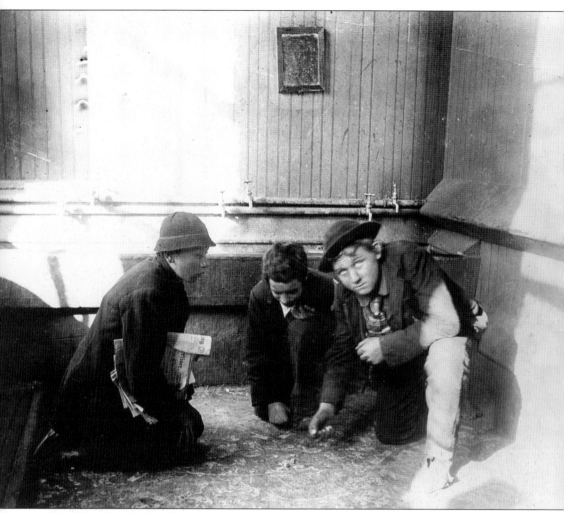

NEWS BOYS. Jacob Riis photographed these newspaper boys shooting craps in the hallway of the news boys' lodging house. Many of the boys had emigrated from Ireland, England, or Germany. (Library of Congress.)

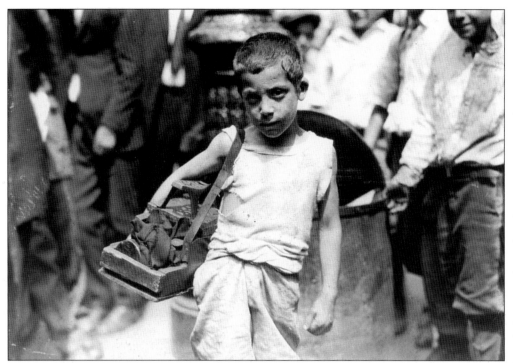

Bootblack in Lower Manhattan. This picture was taken around City Hall Park on July 25, 1924. (Lewis W. Hine photograph, Library of Congress.)

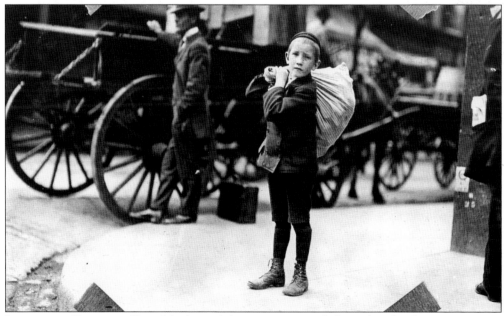

Immigrant Boy with Bag. Manhattan's busy streets provided a multitude of arresting images such as the one shown here in the very early years of the 20th century. (National Park Service.)

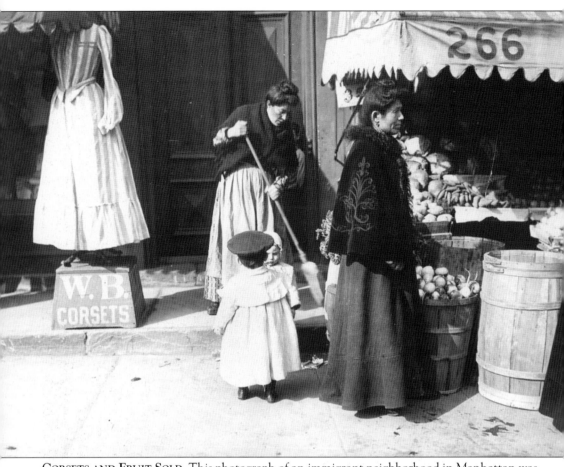

CORSETS AND FRUIT SOLD. This photograph of an immigrant neighborhood in Manhattan was taken early in the 20th century. (Museum of the City of New York.)

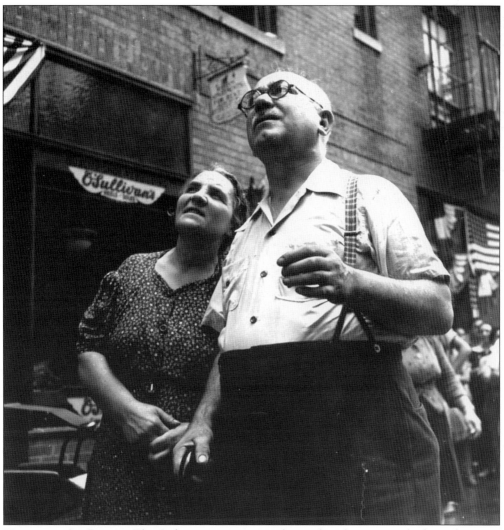

HONORING ST. ROCCO. This Italian immigrant couple watches the raising of a flag in honor of St. Rocco on a rainy August 17, 1942. (Library of Congress.)

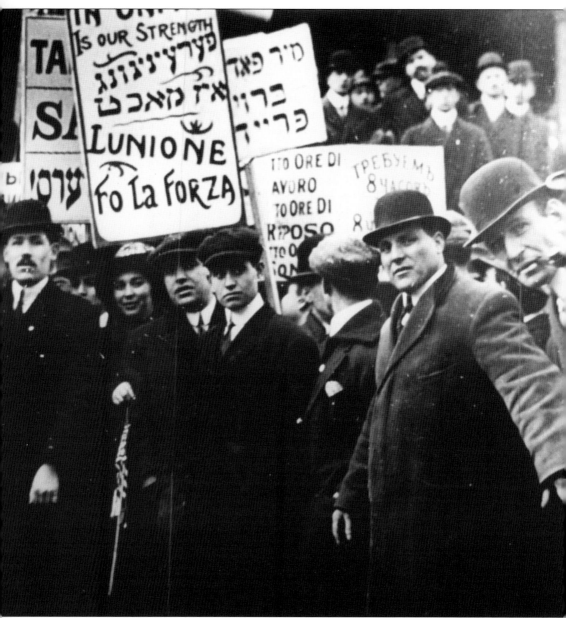

UNION DEMONSTRATORS. These trade union demonstrators are demanding better working hours. Their placards are written in English, Italian, Yiddish, and a Slavic language, most likely Russian or Ukrainian. The Italian words *L'Unione fo la Forza* means "Unity Makes Strength."

Seven

CHILDREN AND
SCHOOL DAYS

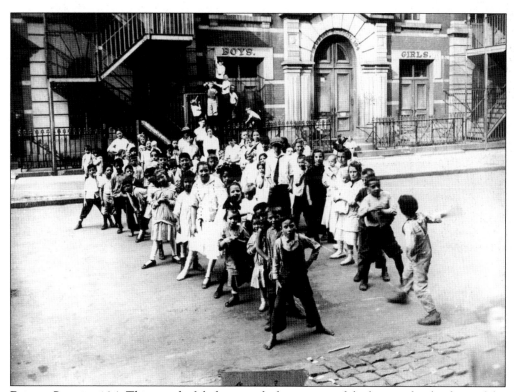

PUBLIC SCHOOL 104. This wonderful photograph shows some of the boys and girls of one of the city's many public schools.

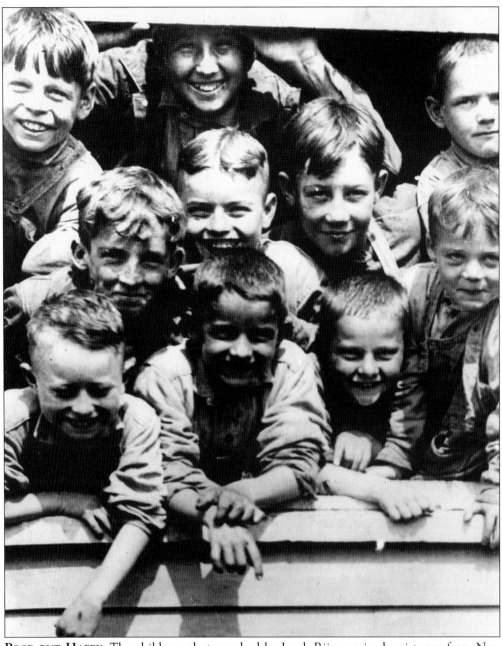

POOR BUT HAPPY. The children, photographed by Jacob Riis, received assistance from New York's Children's Aid Society. (Museum of the City of New York.)

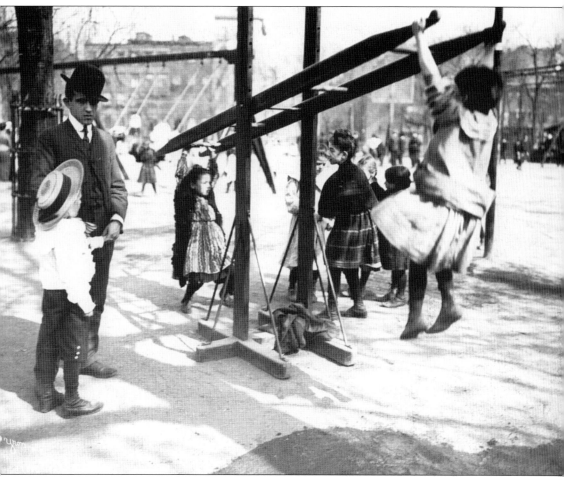

TOMPKINS SQUARE PARK IN 1904. Located in the Lower East Side, Tompkins Square Park had a quite mixed ethnic community that included Irish, Italian, and Jewish immigrants as well as Anglo-Americans.

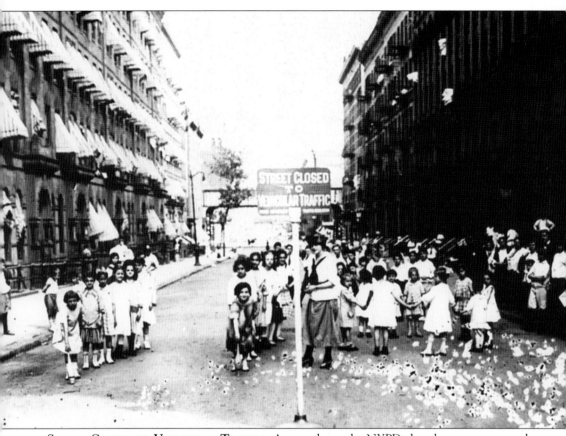

STREET CLOSED TO VEHICULAR TRAFFIC. As seen here, the NYPD closed some streets so that a neighborhoods' many children could enjoy their games without danger.

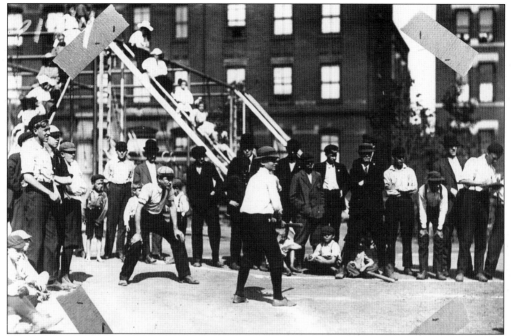

STREET GAMES. The picture above shows teenaged boys playing their favorite ball game. Below, younger children are playing other games. Among the more popular games were tag, follow the leader, blindman's bluff, stickball, handball, skully, hopscotch, and box ball.

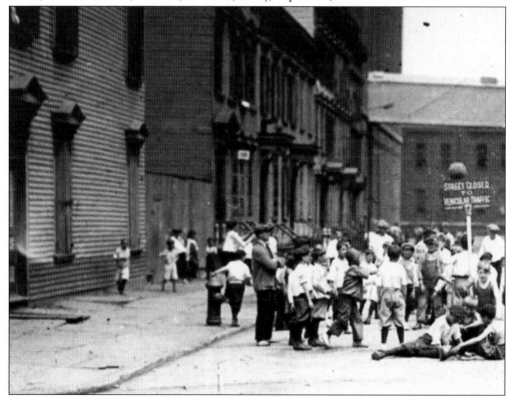

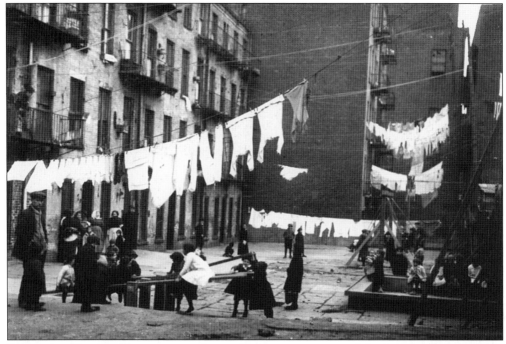

BACKYARD GAMES. Above, some girls are playing on a seesaw while, below, other ones play ring-around-the-rosy or a similar game.

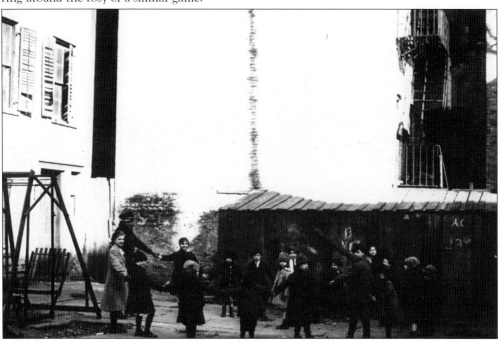

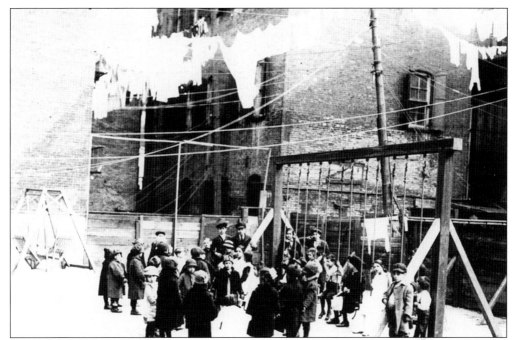

BACKYARD SWING. On a winter's day, a crowd of boys and girls play on a swing while others hold hands in a circle.

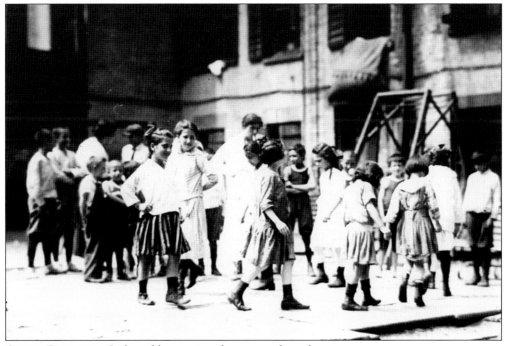

GROUP DANCING. Girls and boys enjoyed games such as these.

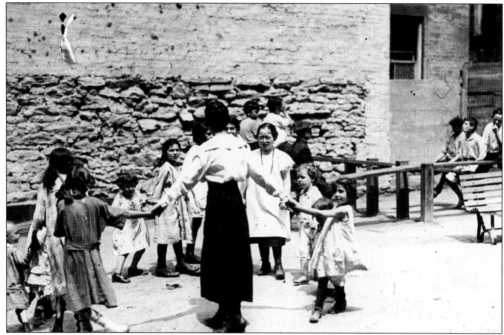

A SMALL CIRCLE OF DANCERS. Teachers taught youngsters how to play together safely. Activities included dancing and games.

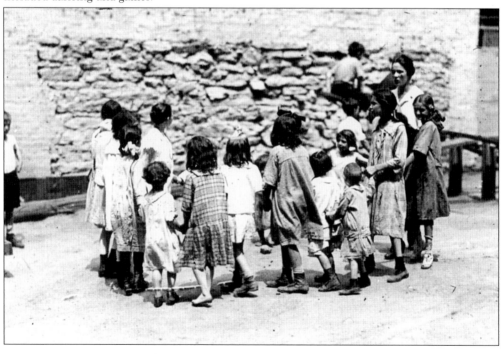

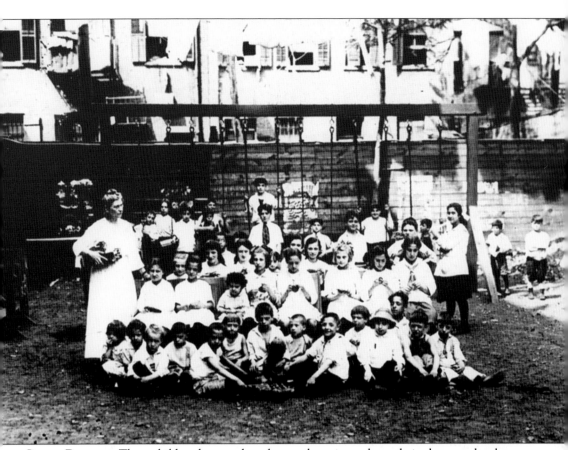

GROUP PICTURE. These children have gathered around a swing to have their photograph taken.

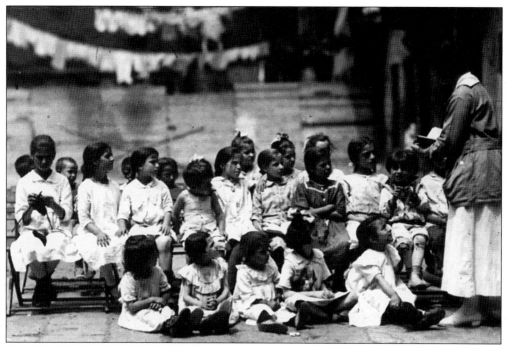

OUTDOOR CLASSES. On hot days, educators taught children in the fresh air. Teachers often read stories to the children and, in the case of girls, had them practice their sewing and knitting, as seen in the photograph below.

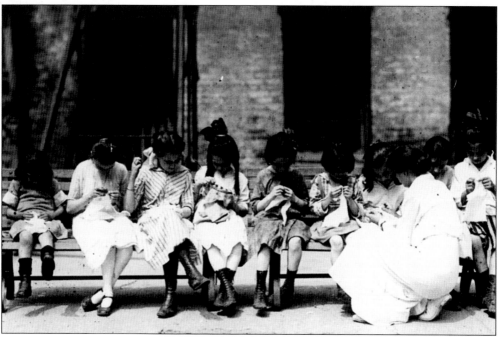

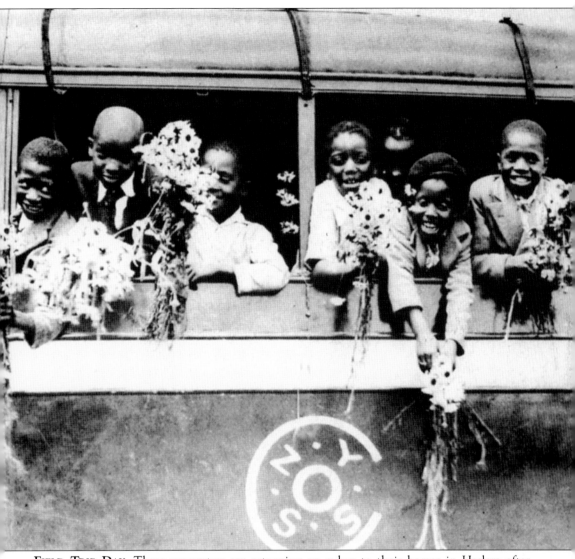

FIELD TRIP DAY. These youngsters are returning on a bus to their homes in Harlem after spending a day in the country, sponsored by the Children's Aid Society. The picture was taken in 1932.

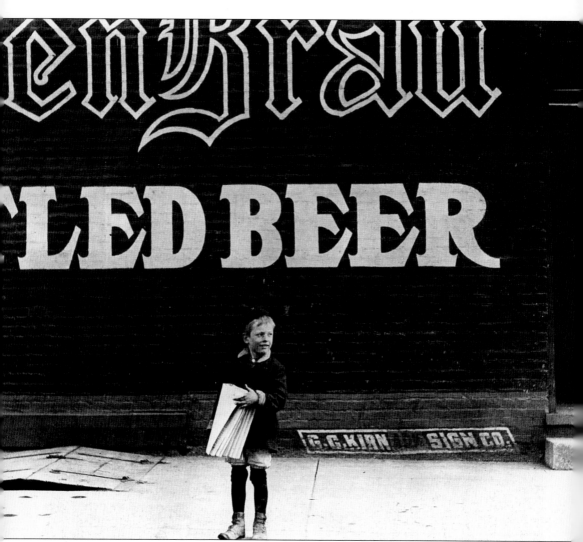

NEWSPAPER BOY. Poor children worked in all sorts of street jobs in Manhattan. Here a young news boy is on the watch for customers. (National Park Service.)

Eight

LONELY STREETS

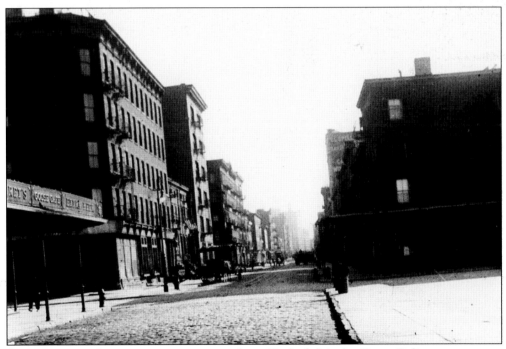

COBBLESTONES. A quiet street scene is seen here. To the left is the Goose Café.

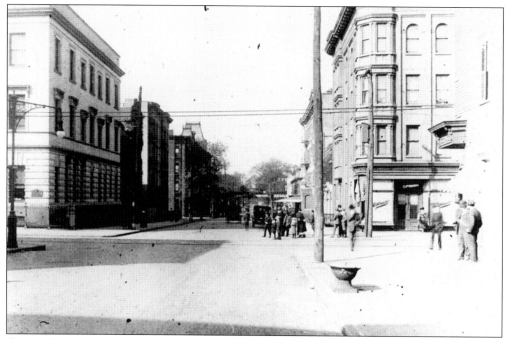

QUIET THOROUGHFARE. A few people stand about in this relatively quiet street.

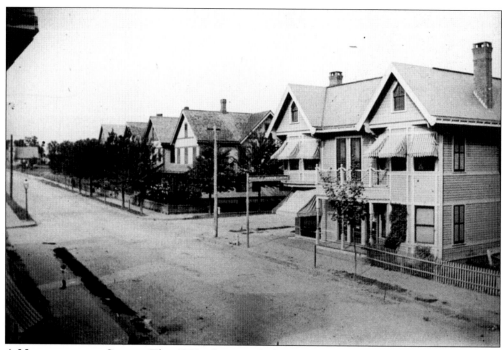

A NEIGHBORHOOD STREET. This 1920s photograph shows some of the houses of the middle class.

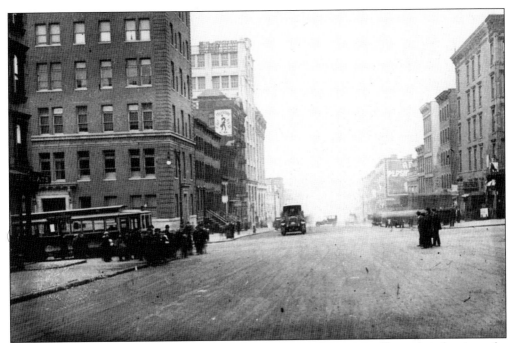

MILDLY BUSY. Although this picture shows a street with some traffic and pedestrians, by Manhattan standards it is still quiet.

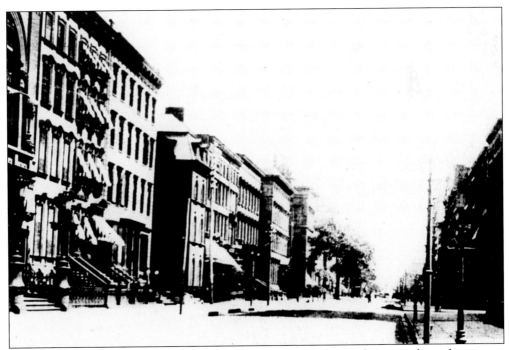

A RESIDENTIAL STREET. A typical street of brownstone apartment houses is shown here.

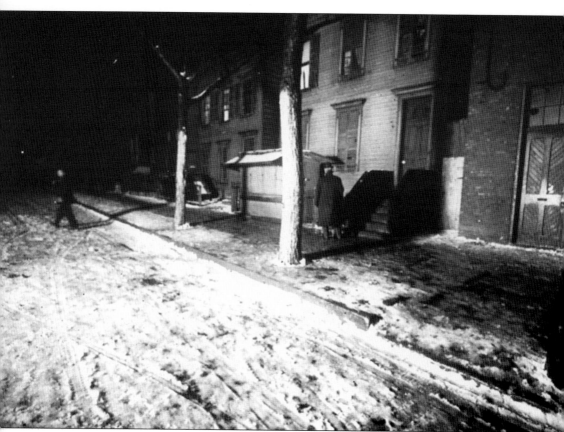

A WINTER'S NIGHT. Two men trudge homeward on a cold winter night in the 1920s.

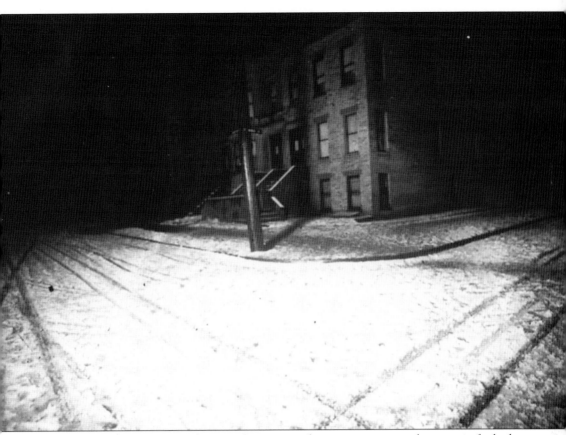

THE EMPTY STREET. Taken at the same location as the previous image, this picture finds the street in total solitude.

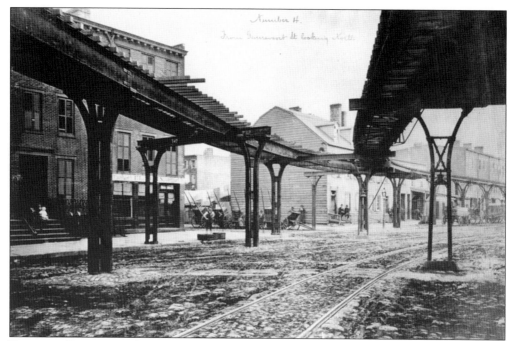

ELEVATED RAILWAYS. These elevated railways stood in Gansevoort Street, a dark, melancholy thoroughfare located in Manhattan's meatpacking district. The cameraman that took this picture was facing north.

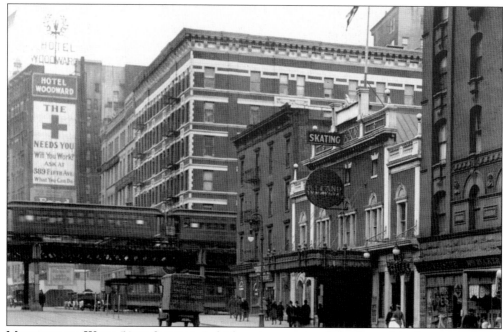

MORNING ON WEST 50TH STREET. A fairly quiet morning in midtown Manhattan is shown here. Signs of commerce and trade include the famous Iceland Skating Rink, the Hotel Woodward, and a van from the Palace Storage Warehouse Company. The photograph was taken on March 4, 1918.

Nine

ENTERTAINMENT

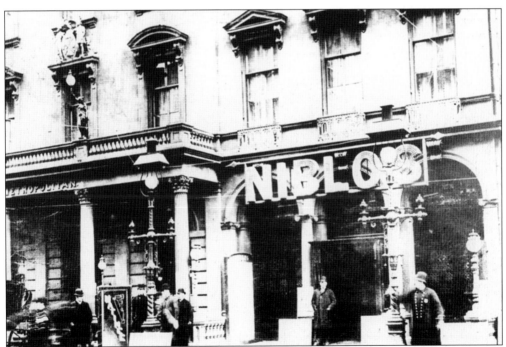

NIBLO'S GARDEN. This picture was taken around the 1880s. Years earlier, in 1829, Irish immigrant and theatrical impresario William Niblo founded his legendary theater, located at the corner of Prince Street and Broadway. It was destroyed in a fire in 1846, and in 1849, the new Niblo's pictured here was opened. Some of the greatest stars of the 19th century performed at Niblo's, including Joseph Jefferson, Charles Kean, Edwin Forrest, Charlotte Cushman, and Adelina Patti. The theater was demolished in 1895.

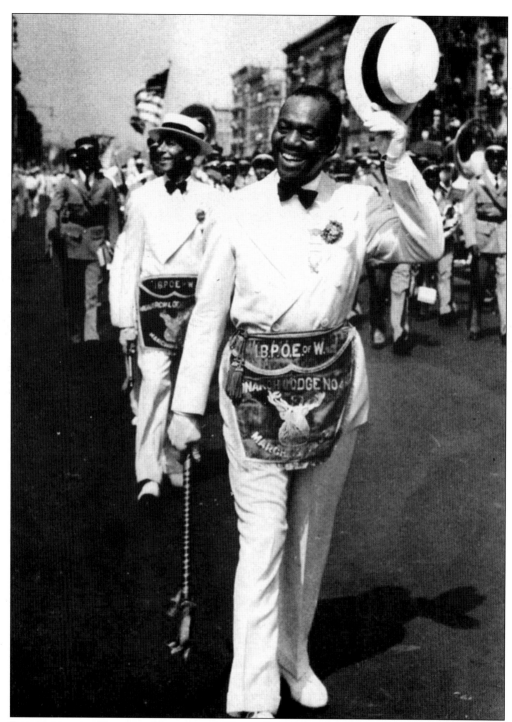

BOJANGLES ON PARADE. Dancer Bill "Bojangles" Robinson marches in the Elks parade in Harlem. Robinson was for many years a top tap dancer in vaudeville, on Broadway, and in motion pictures. He was also an active member of the Order of the Elks, a well-known fraternal society.

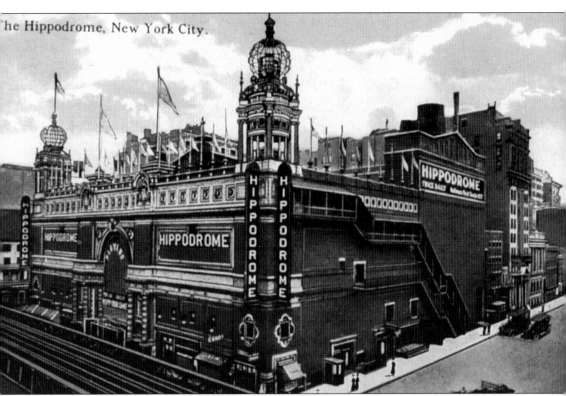

THE HIPPODROME. The Hippodrome was the world's largest theater and was famous for its spectacles. For instance, the great Harry Houdini made a 10,000-pound elephant vanish into thin air as the high point of his act in 1917–1918. The wondrous Hippodrome contained separate theaters for the legitimate stage and vaudeville acts, as well as two circus rings. It was famous for its extravaganzas, including the famous Broadway show *Jumbo* that was staged there in 1935. Opened in 1905, it remained a major showplace until it was finally closed in 1939.

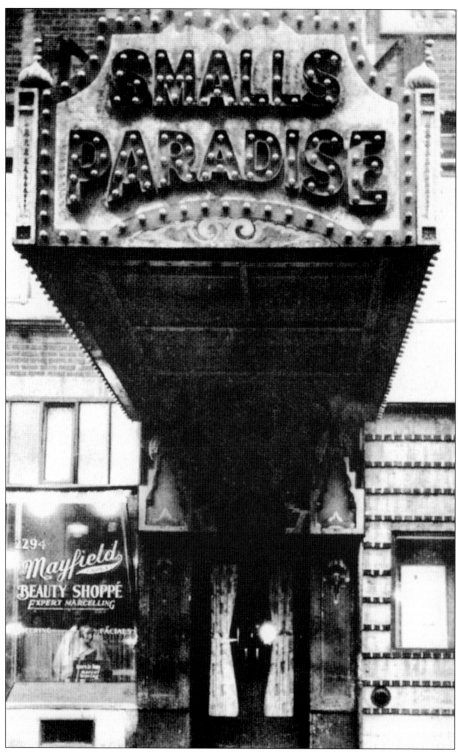

SMALL'S PARADISE. This famous 1920s nightclub attracted crowds of people to Harlem. Featuring noted jazz bands, talented dancers, singers, and comedians, it helped make Harlem famous.

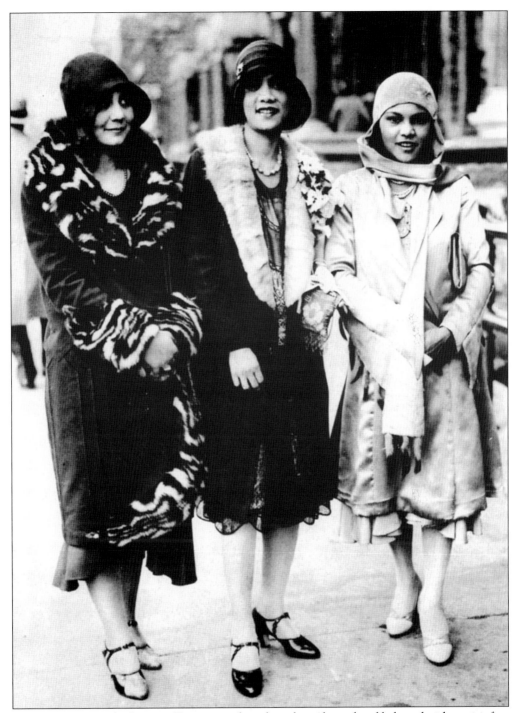

FLAPPERS. During the Roaring Twenties, girls such as these dressed and behaved with a spirit free from Victorian restraint. They sported far shorter dresses than had been worn before, danced the Charleston, and went to speakeasies and nightclubs. These flappers were photographed in 1927.

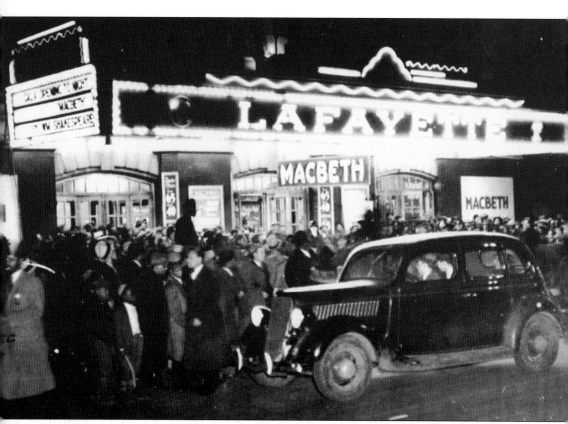

LAFAYETTE THEATRE. This picture of the Lafayette Theatre, a famous vaudeville house in Harlem, was taken in 1936. As can be seen here, the theater had forsaken vaudeville for Shakespeare's *Macbeth*. The car is a 1935 Ford sedan. In its earlier years, black vaudeville stars such as comedian Tim Moore, blues singer Bessie Smith, and tap dancer Willie Covan headlined there.

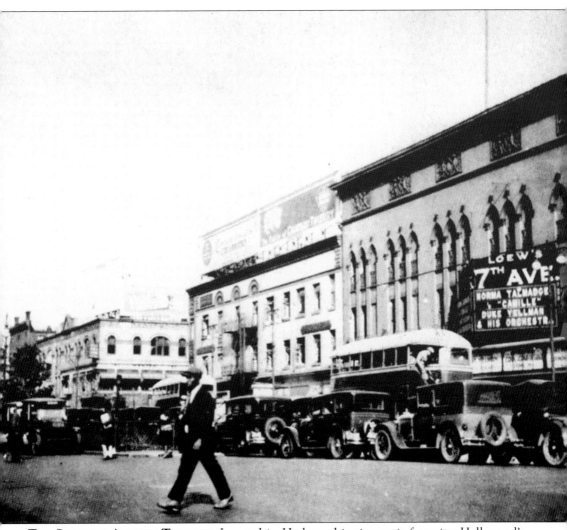

THE SEVENTH AVENUE THEATRE. Located in Harlem, this cinema is featuring Hollywood's 1927 hit film *Camille*, which was a major vehicle for screen star Norma Talmadge.

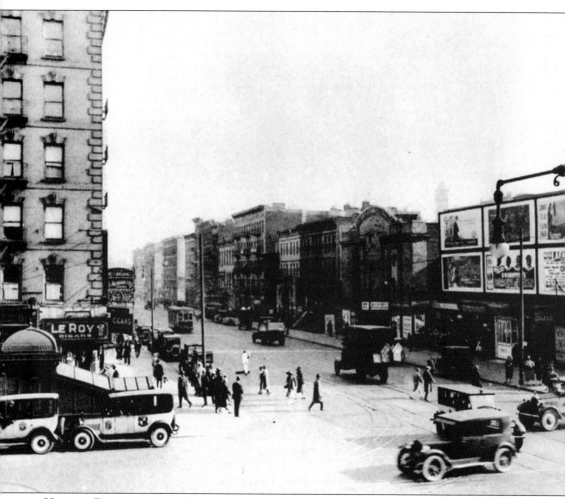

HARLEM ENTERTAINMENT DISTRICT. Automobile and pedestrian traffic at Lenox Avenue and 135th Street is shown here. On the right is a large advertisement for a new vaudeville show, *Desires of 1927*, which featured singer Adelaide Hall.

Ten

PARADES AND
SPECTACLES

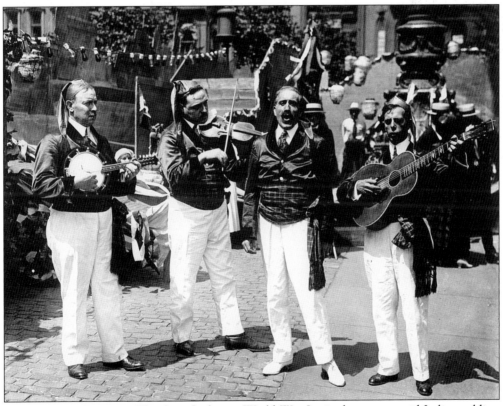

ITALIAN WAR BENEFIT. This benefit during World War I raised money to aid Italian soldiers wounded during the war. The *festa* took place on the grounds of the New York Public Library's main branch at Fifth Avenue and 42nd Street. (War Department/National Archives.)

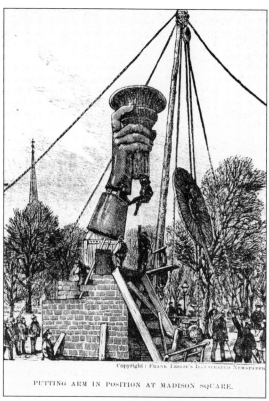

Copyright: Frank Leslie's Illustrated Newspaper

PUTTING ARM IN POSITION AT MADISON SQUARE.

LIBERTY'S TORCH IN MADISON SQUARE. From 1877 to 1882, the Statue of Liberty's torch was placed on public display in Madison Square at 23rd Street. It was then returned to France and mounted on the statue. The completed statue was then presented for public view and celebration to Parisians in 1884. Finally, it was shipped to New York, where it was reassembled in 1886 and inaugurated to tremendous celebration on October 28, 1886.

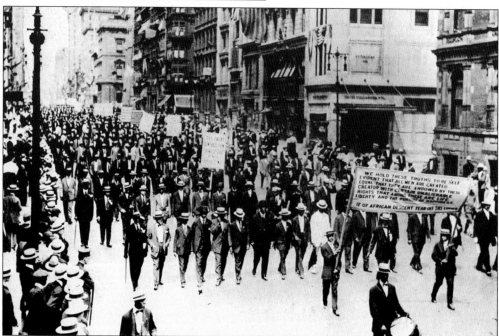

HARLEM PROTEST MARCH. In 1917, these New Yorkers march in protest of the dreadful East St. Louis race riot. The riot, which occurred in July 1917, resulted in the massacres of at least 39 blacks and nine whites.

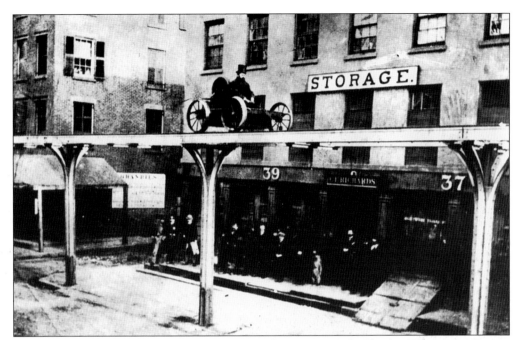

EARLY MOTOR VEHICLE. Pictured here is civil engineer Col. Charles Thompson Harvey (1829–1912) giving a public demonstration of one of his experimental cable car trucks, which he drove on New York's first elevated railway—his own invention. The picture was taken in the year 1868 where Greenwich and Morris Streets meet.

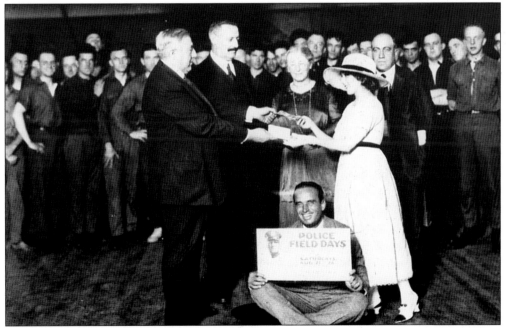

POLICE FIELD DAYS ANNOUNCED. Film stars Mary Pickford and Douglas Fairbanks join the police commissioner to help promote police field days during the month of August. During field days, policemen engaged in all sorts of sporting events and competitions, including footraces, tugs of war (ropes pulling), and baseball.

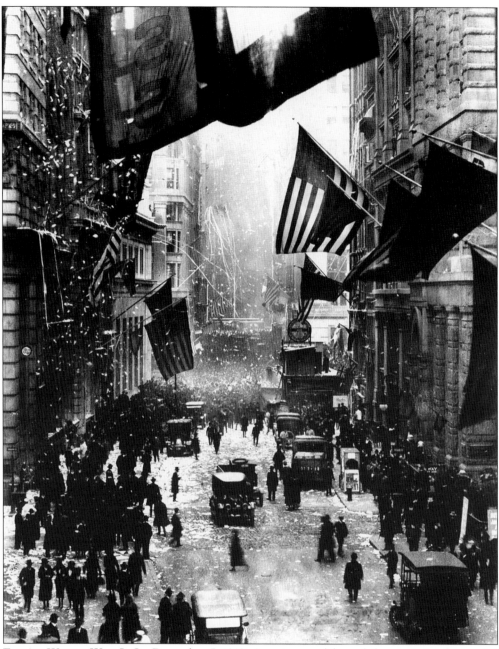

END OF WORLD WAR I. On December 5, 1918, Americans celebrated the armistice that ended the Great War with a ticker tape parade in Wall Street. Germany actually signed the armistice ending its war against France and its allies on November 11. (Library of Congress.)

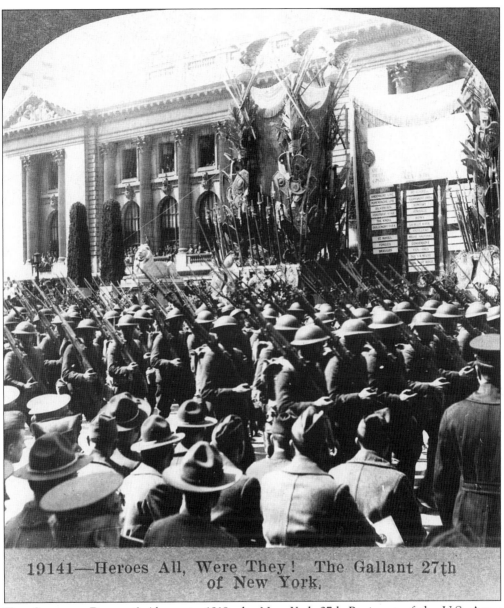

19141—Heroes All, Were They! The Gallant 27th of New York.

THE SOLDIERS RETURN! Above, in 1918, the New York 27th Regiment of the U.S. Army marches past the New York Public Library after returning from Europe.

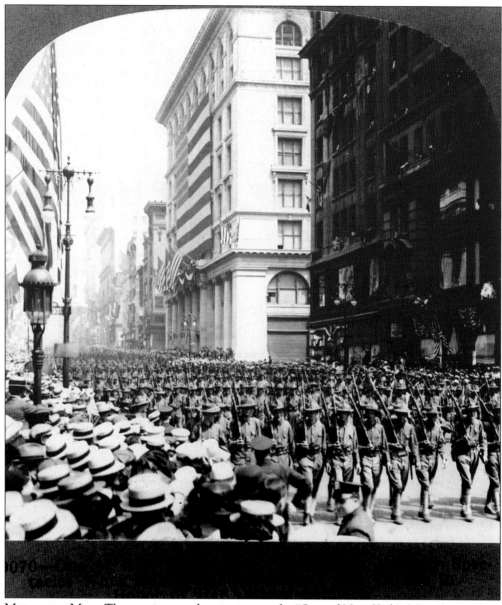

MARCHING MEN. The caption on the pictures reads, "One of New York's Most Stupendous Military Spectacles [Occurred] When Thirty-eight Thousand Men Parade in Honor of Her Citizen Soldiers." (Library of Congress.)

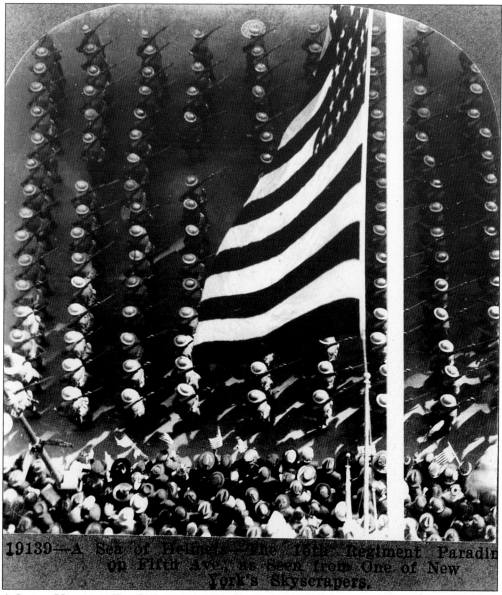

19139—A Sea of Helmets—The 15th Regiment Parading on Fifth Ave., as Seen from One of New York's Skyscrapers.

A SEA OF HELMETS: THE U.S. ARMY 15TH REGIMENT. This photograph from above shows the "sea of helmets" marching along Fifth Avenue in celebration of the victorious end of World War I. (Library of Congress.)

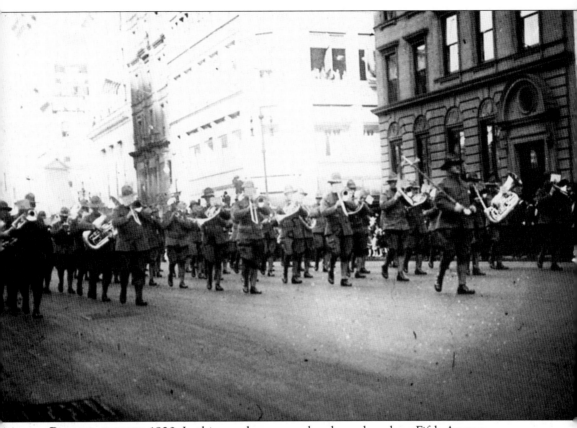

PARADE, AROUND 1920. In this parade, an army band marches along Fifth Avenue.

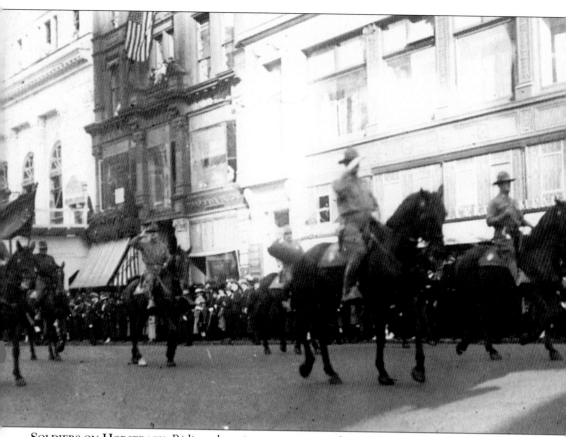

SOLDIERS ON HORSEBACK. Riding along in a patriotic parade on Fifth Avenue, cavalrymen give a salute.

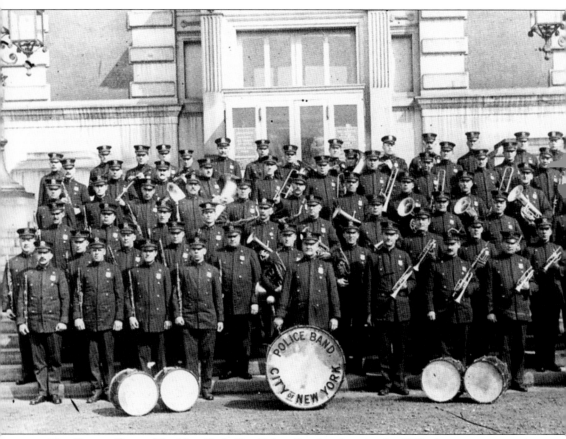

THE POLICE BAND. The New York City Police Band gathers in the 1920s for a group picture.

BIBLIOGRAPHY

Corbett, Ruth. *Daddy Danced the Charleston: A Nostalgic Remembrance of Our Yesterdays.* New York: A. S. Barnes and Company, 1970.

Drowne, Kathleen, and Patrick Huber. *The 1920s: American Popular Culture through History.* Westport, CT: Greenwood Press, 2004.

Erenberg, Lewis A. *Steppin' Out: New York Nightlife and the Transformation of American Culture, 1890–1930.* Chicago: University of Chicago Press, 1981.

Gilder, Rodman. *The Battery.* Boston: Houghton Mifflin, 1936.

Homberger, Eric. *The Historical Atlas of New York City: A Visual Celebration of Nearly Four Hundred Years of New York City's History.* New York: Henry Holt and Company, 1994.

Jackson, Kenneth T., editor. *The Encyclopedia of New York City.* New Haven, CT: Yale University Press, 1995.

Lankevich, George J., and Howard B. Furer. *A Brief History of New York City.* New York: Associated Faculty Press, 1984.

Lardner, James, and Thomas Reppetto. *NYPD: A City and Its Police.* New York: Henry Holt and Company, 2000.

Marcuse, Maxwell F. *This was New York: A Nostalgic Picture of Gotham in the Gaslight Era.* New York: Carlton Press, 1965.

Morand, Paul. *New York.* New York: Henry Holt and Company, 1930.

Riesenberg, Felix, and Alexander Alland. *A Portrait of New York.* New York: Macmillan, 1939.

Tauranac, John. *Manhattan Block by Block.* New York: Tauranac Maps, 2000.

Van Hoogstraten, Nicholas. *Lost Broadway Theatres.* New York: Princeton Architectural Press, 1997.

INDEX

ACROSS AMERICA, PEOPLE ARE DISCOVERING SOMETHING WONDERFUL. *THEIR HERITAGE.*

Arcadia Publishing is the leading local history publisher in the United States. With more than 3,000 titles in print and hundreds of new titles released every year, Arcadia has extensive specialized experience chronicling the history of communities and celebrating America's hidden stories, bringing to life the people, places, and events from the past. To discover the history of other communities across the nation, please visit:

www.arcadiapublishing.com

Customized search tools allow you to find regional history books about the town where you grew up, the cities where your friends and family live, the town where your parents met, or even that retirement spot you've been dreaming about.